How to Draw
CARTOONS
for COMIC STRIPS

How to Draw
CARTOONS
for COMIC STRIPS

Christopher Hart

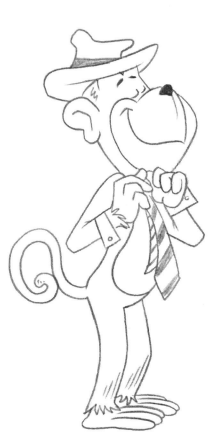

WATSON-GUPTILL PUBLICATIONS/NEW YORK

This book is dedicated
to my mother, Joan Hart,
who encouraged me to
become an artist, rather
than a doctor or a lawyer.

Copyright © 1988 by Christopher Hart

First published 1988 in New York by Watson-Guptill Publications,
a division of Billboard Publications, Inc.,
1515 Broadway, New York, N.Y. 10036.

Library of Congress Cataloging-in-Publication Data

Hart, Christopher.
 How to draw cartoons for comic strips.
 Includes index.
 1. Cartooning—Technique. I. Title.
NC1320.H35 1988 741.5 88-14238
ISBN 0-8230-2354-0
ISBN 0-8230-2353-2 (pbk.)

Distributed in the United Kingdom by Phaidon Press Ltd., Littlegate
House, St. Ebbe's St., Oxford

Manufactured in the United States of America.

First Printing, 1988

4 5 6 7 8 9 / 93 92 91 90 89

ONTENTS

INTRODUCTION

I picked up my first pencil when I was only three years old. I stuck it in my mouth and ate the eraser. Took me a few more years before I realized I should draw with it. That was infinitely more fun, and besides, those erasers really bloat you up.

So I began to doodle. I doodled on everything. I doodled on my schoolbooks, on my parents' checkbooks, all over the living room walls. Needless to say, I got punished a lot—my parents would take away my TV privileges, which left me in my room with nothing to do, except draw. They couldn't win. So draw I did. But after a while, I realized that my drawings weren't improving. That's when I decided to get a little bit of help. So I bought a book.

But that didn't help my drawing one iota. Perhaps that's because it was a book on gardening. I finally did purchase a book on cartooning, but it wasn't much better—and it had far less practical advice on pollination. All in all, I had to work my way through eight different cartoon instruction books to get the tips I needed to draw the way I wanted to.

This book is designed to give you the complete instruction you'll need to draw cartoons for your own comic strip. What's so different about this book? First, most books on cartooning are chauvinistic—they teach you how to draw men, but leave out women. This is a liability, because comic strips today are featuring more and more women as main characters. Second, most cartoon instruction

books rely on decade-old comic strips and extinct animated characters for their models. And most important, none of the books I encountered as an art student ever helped me to design my own characters, which is perhaps the most rewarding achievement for any cartoonist.

This book, on the other hand, will show you how to draw men and women, young and old characters, humans as well as animals. All the cartoons in this book keep pace with the newest and boldest comic strips in the funny pages today. And the instruction is always focused to help you eventually invent your own unique comic strip characters.

I encourage you to copy the constructions in this book freehand, but whatever you do, don't trace anything! If your drawings come out a little sloppy at first—good! They're supposed to. If you can do them perfectly the first time out, then you should be writing a book, too. Also, concentrate first on what comes easiest. If, for instance, you find that faces are easy to draw, but hands are not, then draw faces. This will give you the confidence to tackle the tougher drawings later.

You can take this book as far as you like. You can simply improve your doodles, or you can hone your cartoons to the point where they're ready for submission to the major newspaper syndicates. But either way, you'll have hours of fun learning to draw cartoons.

THE BASIC HUMAN HEAD

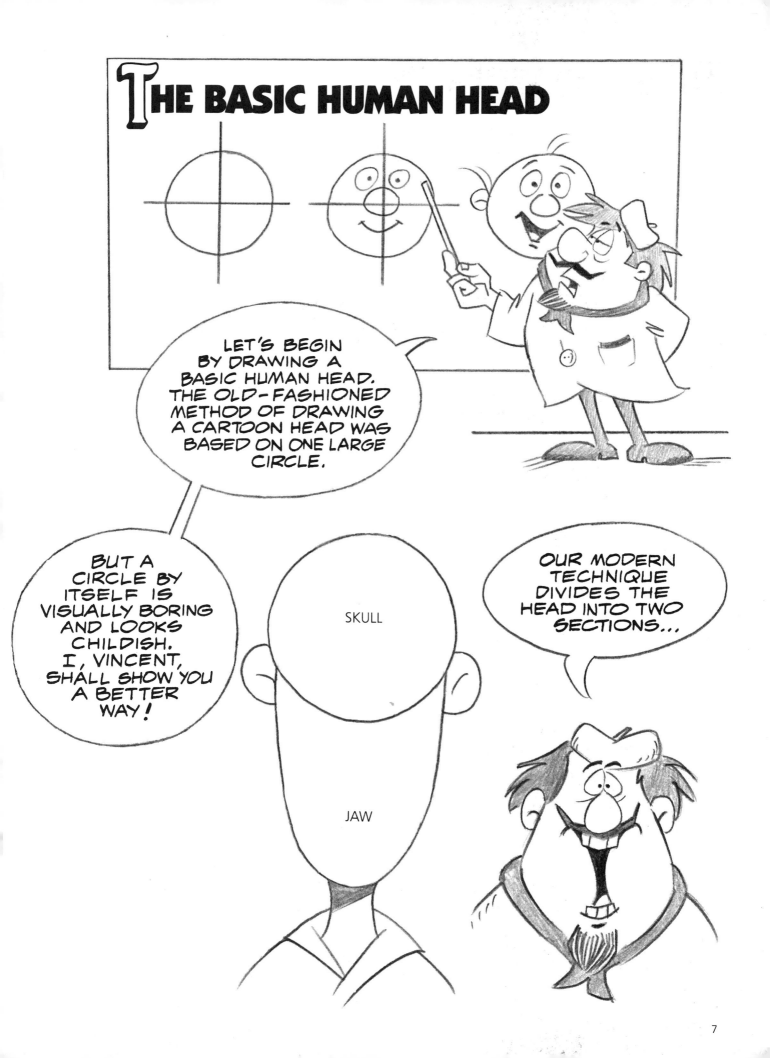

LET'S BEGIN BY DRAWING A BASIC HUMAN HEAD. THE OLD-FASHIONED METHOD OF DRAWING A CARTOON HEAD WAS BASED ON ONE LARGE CIRCLE.

BUT A CIRCLE BY ITSELF IS VISUALLY BORING AND LOOKS CHILDISH. I, VINCENT, SHALL SHOW YOU A BETTER WAY!

SKULL

JAW

OUR MODERN TECHNIQUE DIVIDES THE HEAD INTO TWO SECTIONS...

Skull and Jaw Construction

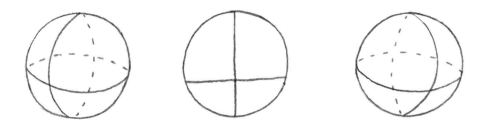

Think of the skull as a three-dimensional globe. Draw in the axis lines, which will help you position the facial features. The vertical line defines the middle of the face. The horizontal guideline is the eye line—the eyes go above it, the nose below, and the ears on either end. This line usually falls below the center of the globe.

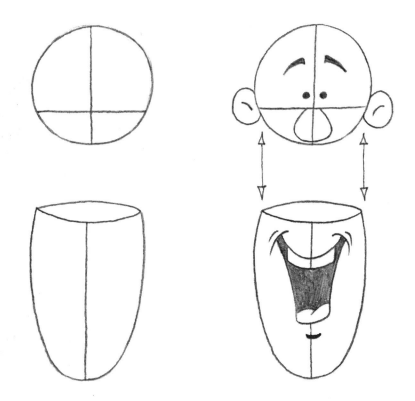

The skull fits snugly into the jaw, and the head is complete!

| profile | ¾ view left | front | ¾ view right | profile |

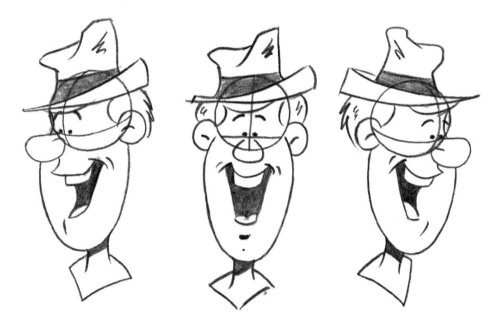

The jaw rotates with the skull as a unit so that the character remains the same no matter what position the head is in. Keeping the head consistent is the secret that enables cartoonists to draw the same character over and over again without losing its identity. Sometimes people have great difficulty drawing a character in different positions. That's because they don't use these foundations, which means the process can be pretty much hit and miss. But we're about to change all that . . .

Front View (Male)

Always begin by drawing
a general outline;
then add details.

*Start with a basic
skull-jaw combination.*

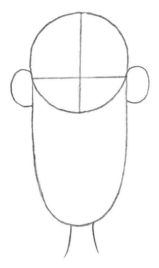

Add the ears and neck.

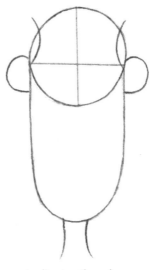

*Indicate the slope
of the forehead.*

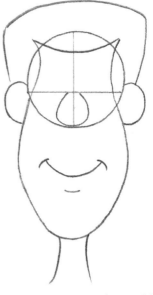

*Add the nose, mouth, and hair.
Adjust the cheeks to suit
the expression. For instance,
a smile causes the cheeks
to widen.*

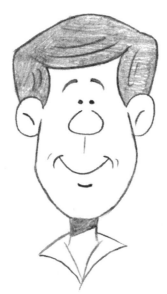

*Finish up with the eyes and
eyebrows. Add shading under the
neck for a professional look.*

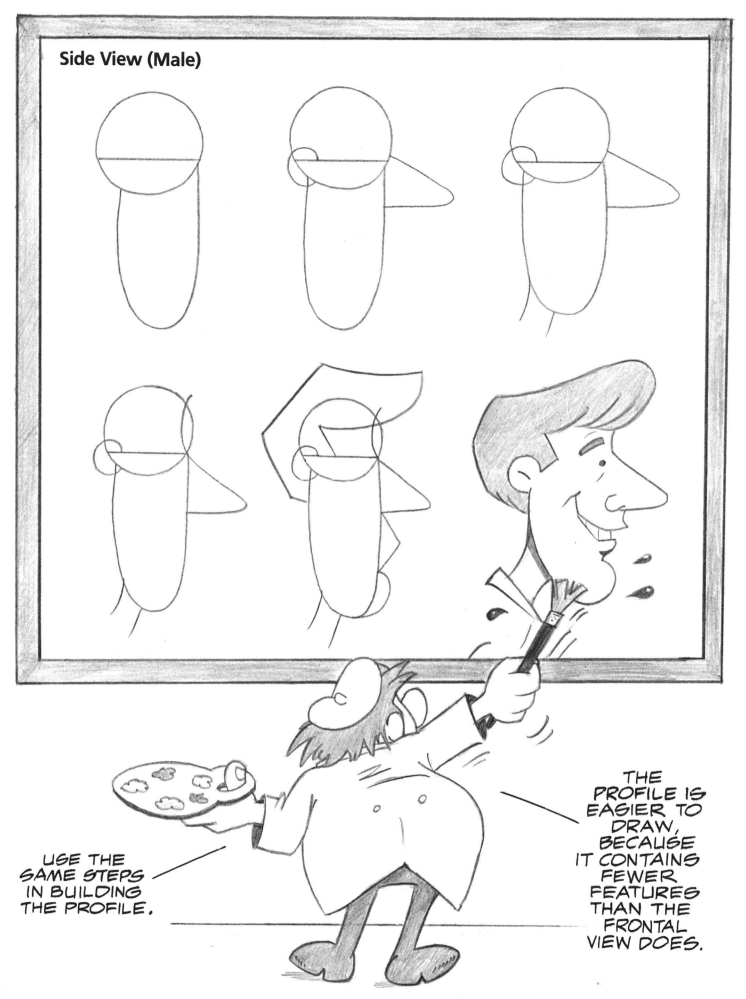

Side View (Male)

USE THE SAME STEPS IN BUILDING THE PROFILE.

THE PROFILE IS EASIER TO DRAW, BECAUSE IT CONTAINS FEWER FEATURES THAN THE FRONTAL VIEW DOES.

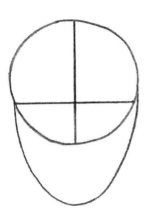

Start with the skull and jaw.

Front View (Female)

Although a woman's head has basically the same structure as a man's, the female jaw is narrower and the chin is less pronounced. Drawing a stereotypical lady requires exaggerated treatment of the lips, eyes, and hair. On the other hand, the nose, ears, and neck should be minimized.

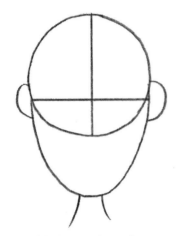

Add the neck and ears.

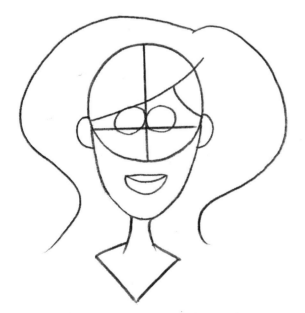

Add the hair, eyes, and mouth.

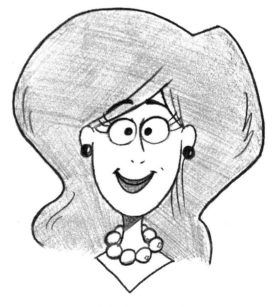

And fill in the details.

Side View (Female)

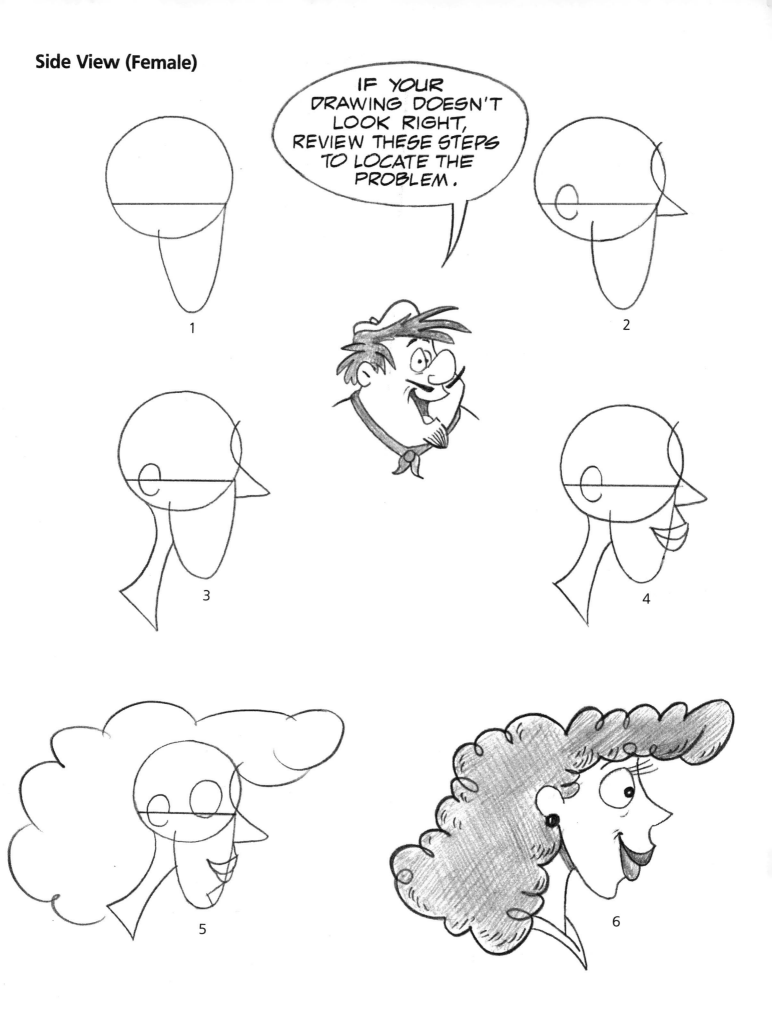

IF YOUR DRAWING DOESN'T LOOK RIGHT, REVIEW THESE STEPS TO LOCATE THE PROBLEM.

1

2

3

4

5

6

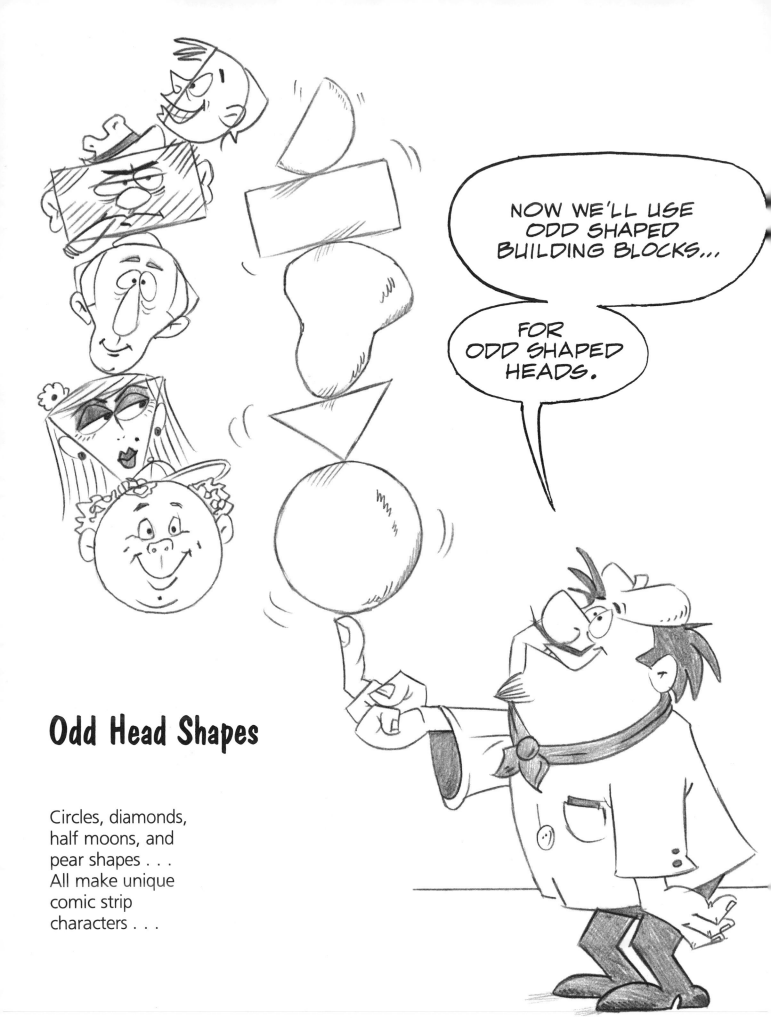

Odd Head Shapes

Circles, diamonds,
half moons, and
pear shapes . . .
All make unique
comic strip
characters . . .

Diamonds

lend a particularly feminine look, because the chin is tapered and the cheekbones are accentuated.

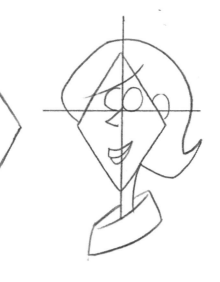

Sloppy circles

can be used to create characters with big cheeks and an exuberant spirit.

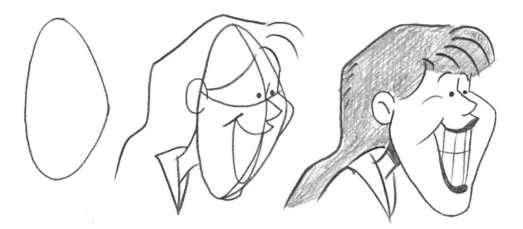

Half moons

are best used for profiles. Remember that half moons turn into full moons when the character faces forward.

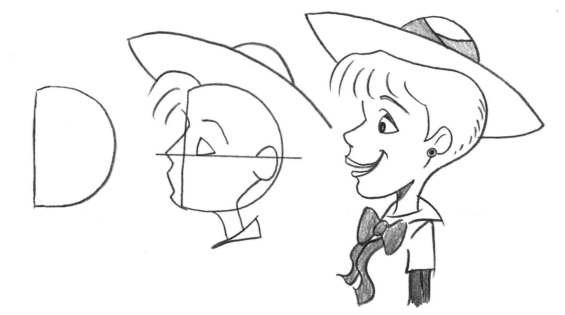

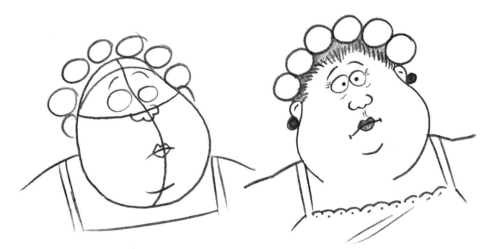

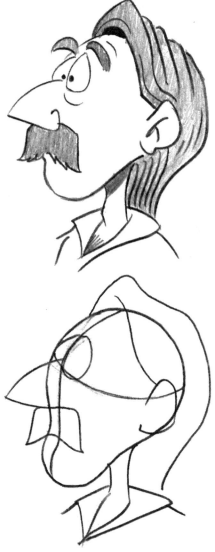

Pears
are the most common
and versatile shape
used for heads.

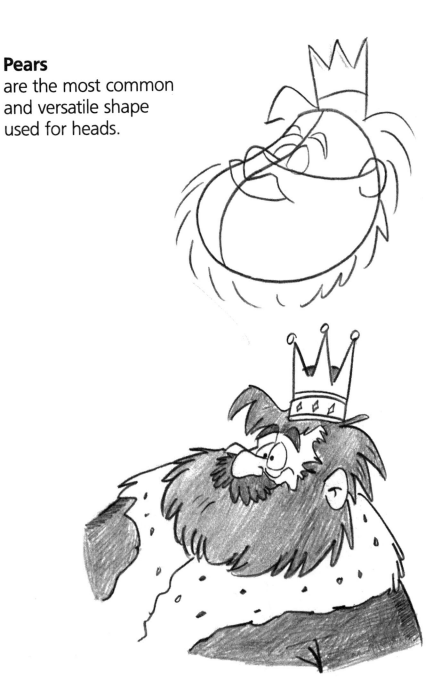

See what happens when you
turn the pear upside down.

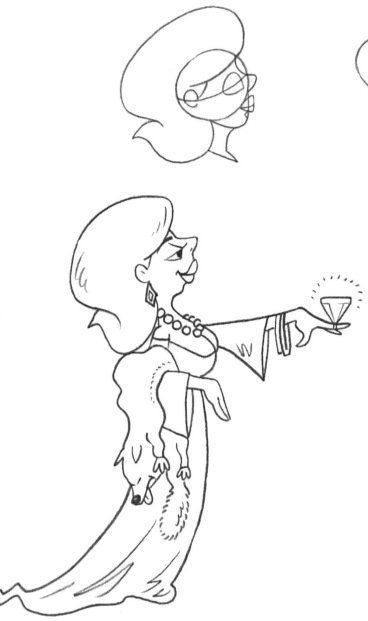

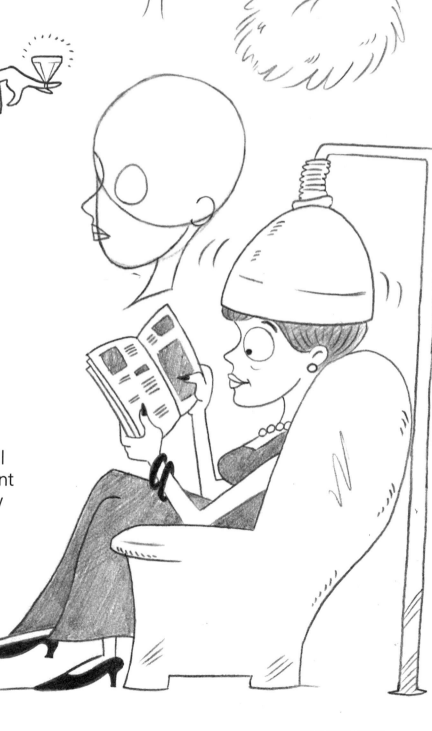

Vary the sizes of the skull and jaw to create different characters. Try these new head constructions.

This lady is all skull, and the drawing works because her eyes fill up her forehead.

This character, on the other hand, has a large jaw and a very small skull. His wild smile, crooked lips, crossed eyes, and disheveled hair all add to his crazy expression.

Like the above character, this guy has a small skull and a big jaw. So what sets the two characters apart? Can you tell? The difference is that the character at left has a small mouth. Remember, the jaw is part of the structure of the head, while the mouth is only a feature.

FACIAL FEATURES

BY STYLIZING THE FACIAL FEATURES THAT APPEAR INSIDE THE HEAD CONSTRUCTION, YOU CREATE MUCH MORE INTERESTING COMIC STRIP CHARACTERS.

Eye Types

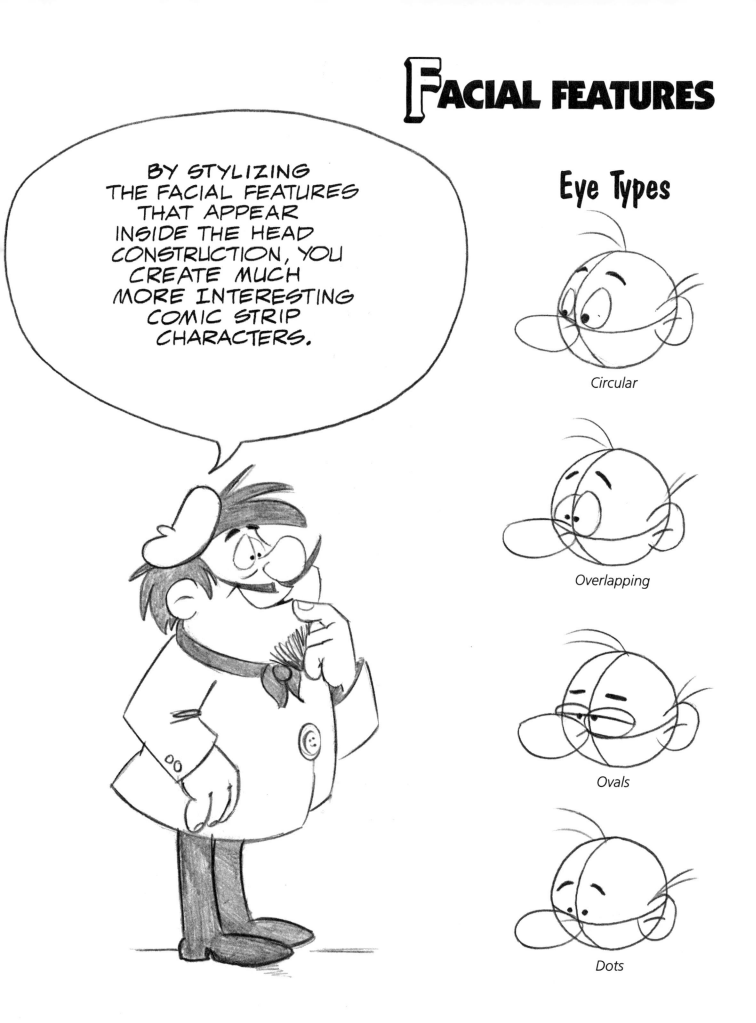

Circular

Overlapping

Ovals

Dots

The Mouth

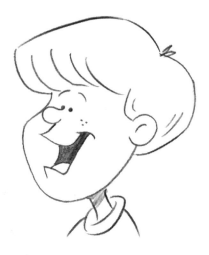

Contrary to the popular notion that the eyes are the most expressive part of the face, the mouths of comic strip characters usually convey the emotions best. In fact, some famous comic strip characters have no eyes at all. Think about Mort Walker's classic, "Beetle Bailey."

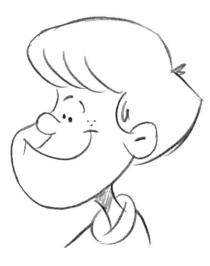

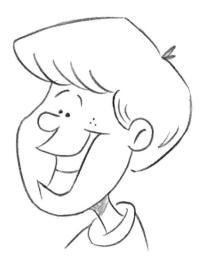

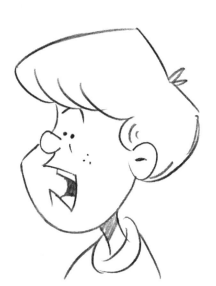

See how you can change a character's expression by changing only the mouth.

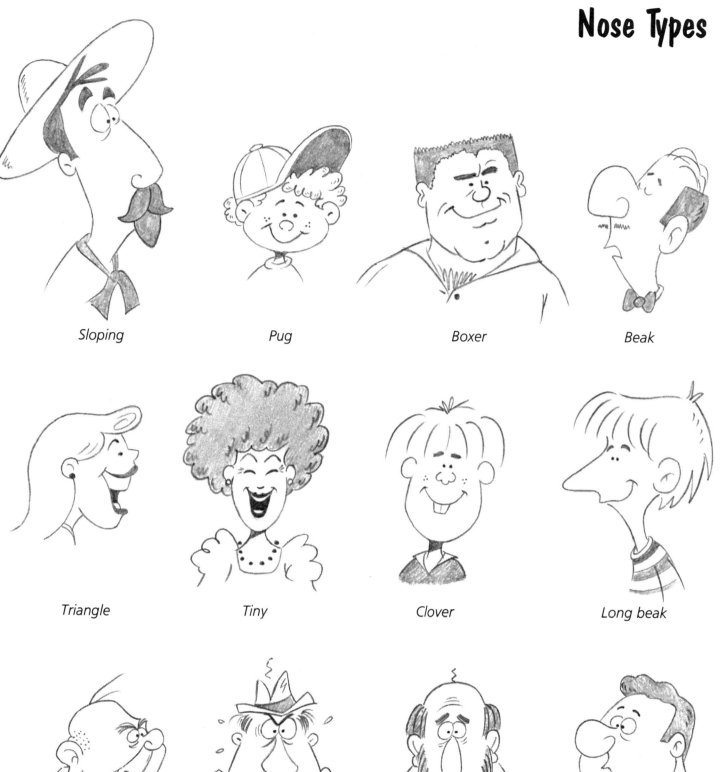

Sloping

Pug

Boxer

Beak

Triangle

Tiny

Clover

Long beak

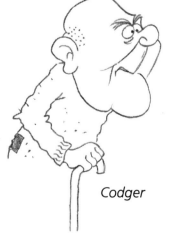

Codger

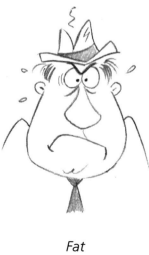

Fat

Drooping

Clown

BEARDS

CAN DRAMATICALLY ALTER A CHARACTER'S APPEARANCE. ALL THESE HEADS HAVE SIMILAR CONSTRUCTIONS AND FEATURES. ONLY THE BEARDS ARE DIFFERENT--AND WHAT A DIFFERENCE THEY MAKE!

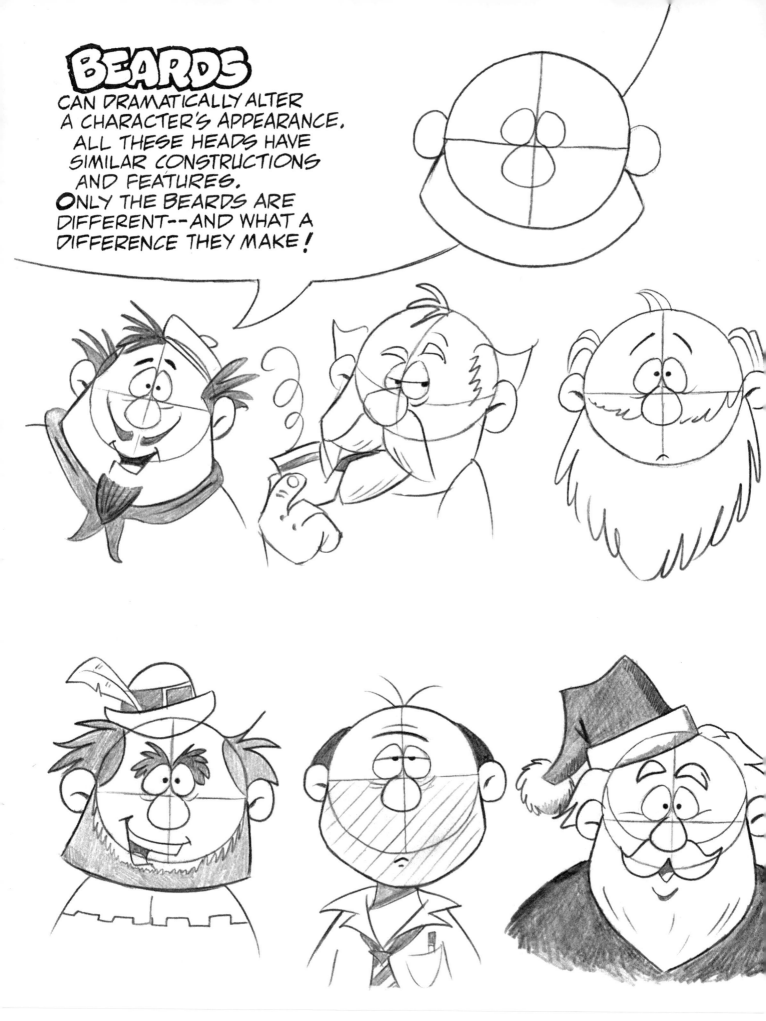

Moustaches

Sometimes a moustache acts as the upper lip, taking the shape of the mouth; other times, it's just an ornament.

THE HAND

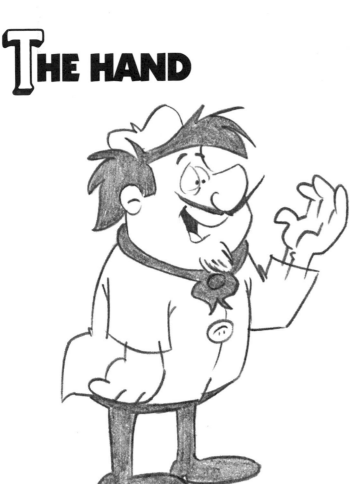

IF THERE IS ONE THING THAT HAS CONFOUNDED EVERY ARTIST AT SOME POINT, IT'S THE HAND!

The hand, when drawn by cartoonists, has only three fingers. A simpler hand helps keep the drawing uncluttered, and by now the three-finger hand is standard.

Just as the torso is the foundation of the body, so the palm is the foundation of the hand.

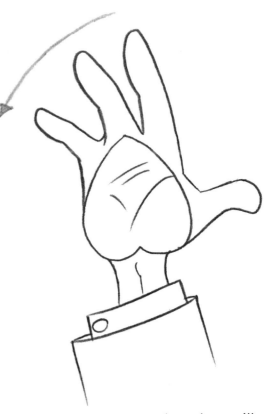

Draw the palm as an upside-down heart; then add the fingers and thumb.

If you look at your own hand, you'll see that your middle finger is the longest. To create a hand with only three fingers, you must eliminate the index finger.

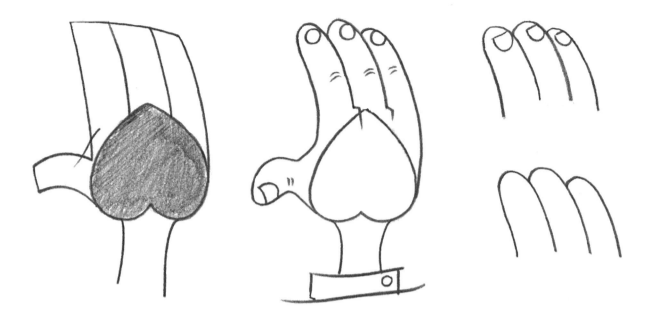

There are three basic types of cartoon fingernails: the circular nail, the straight-edge nail, and the most popular, no nail at all.

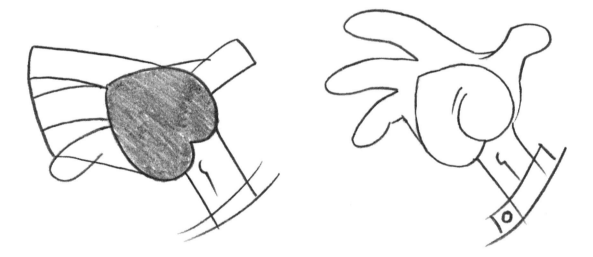

Now, start separating the fingers and rotating the hand to vary the gestures.

Hands can be as expressive as the face and just as important to a successful drawing. Study these gestures.

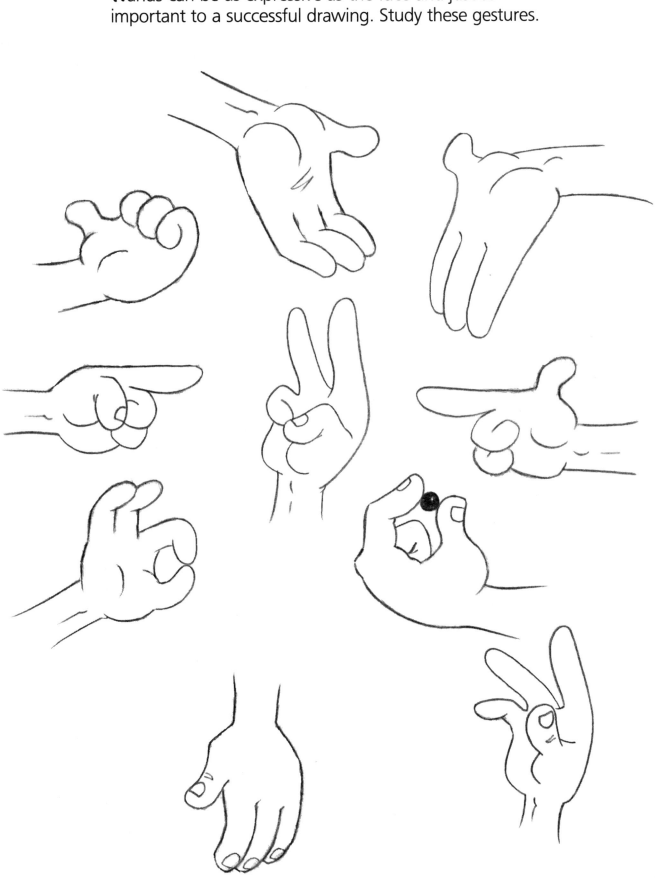

THE LOWER LEG AND FOOT

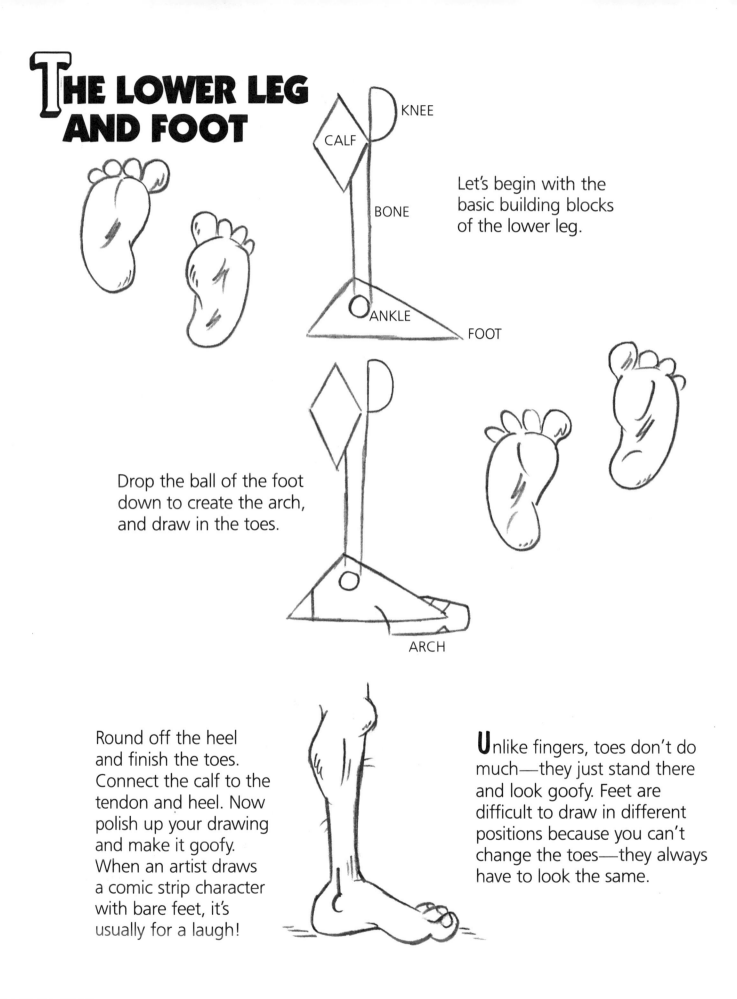

CALF

KNEE

BONE

ANKLE

FOOT

Let's begin with the basic building blocks of the lower leg.

Drop the ball of the foot down to create the arch, and draw in the toes.

ARCH

Round off the heel and finish the toes. Connect the calf to the tendon and heel. Now polish up your drawing and make it goofy. When an artist draws a comic strip character with bare feet, it's usually for a laugh!

Unlike fingers, toes don't do much—they just stand there and look goofy. Feet are difficult to draw in different positions because you can't change the toes—they always have to look the same.

Here are two more foot positions you're likely to encounter. The one on the left is fairly straightforward; it's the reverse of the pose on the facing page. The foot on the right, however, is trickier to draw. This time, you'll have to make a foreshortened drawing by enlarging the front of the foot and reducing the back. In this drawing, the big toe appears large, while the other toes seem to disappear behind it. Also notice that the ball of the foot is prominent, while the heel is minimized.

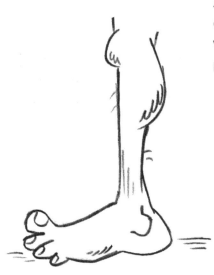

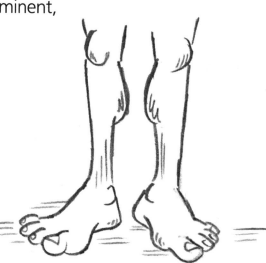

THE BODY BEAUTIFUL

Now that you have a basic idea of how to draw the head, hands, and feet, let's put them where they belong—on the body.

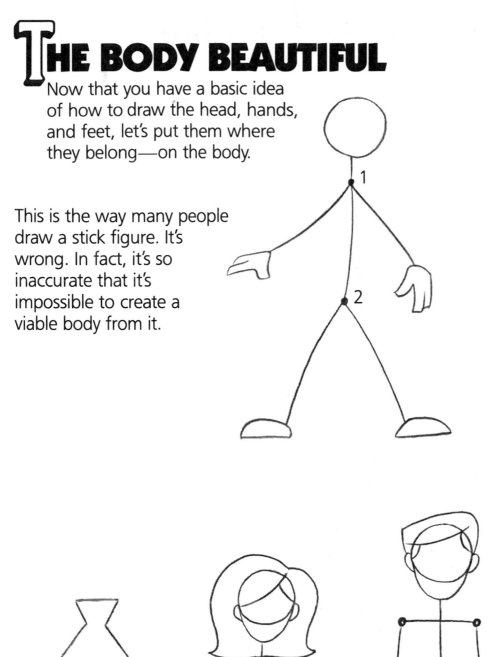

This is the way many people draw a stick figure. It's wrong. In fact, it's so inaccurate that it's impossible to create a viable body from it.

However, it could all be fixed with only two small adjustments:

1. Add a collarbone

2. Add a pelvis

Woman's Body
Narrow shoulders, broad hips

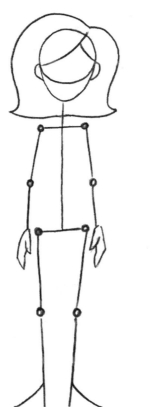

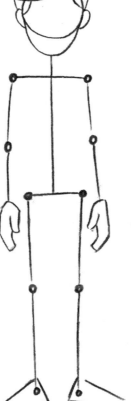

Man's Body
Broad shoulders, narrow hips

Underlying Structure of the Body

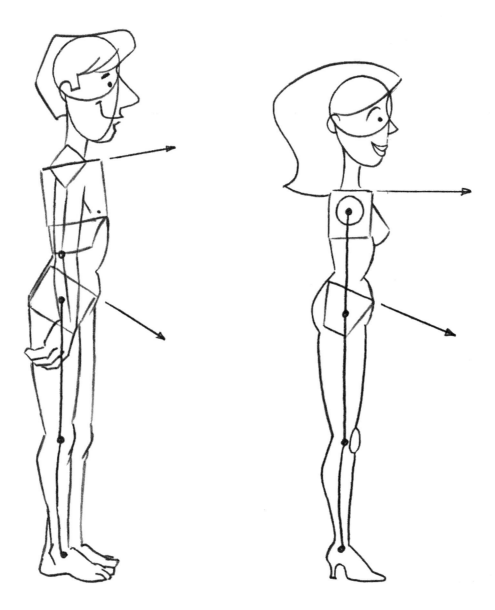

These sketches of the figure in profile are just for reference—you don't need to copy them. The chest and the pelvis are like two boxes that add weight and focus to the body. They are the hidden foundations of the body, just as the skull and jaw are the foundations of the head. Normally, a man's chest tilts upward, while a woman's remains level.

Opposing Shoulders and Hips

To liven up the poses of your characters, adjust the distribution of weight so that more weight is placed on one foot than on the other.

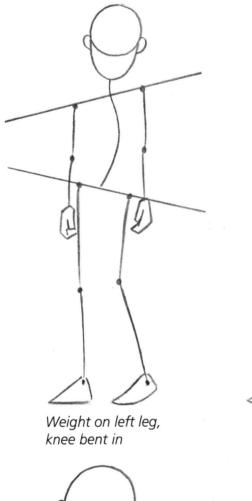

Weight on left leg, knee bent in

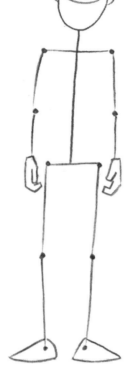

Neutral

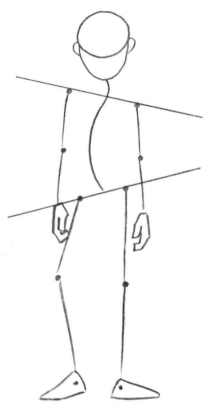

Weight on right leg, knee bent out

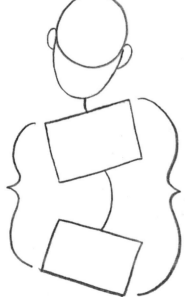

The shoulders and hips oppose each other. This adds a "stretch" to one side of the torso and crimps the other side.

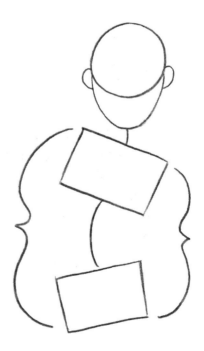

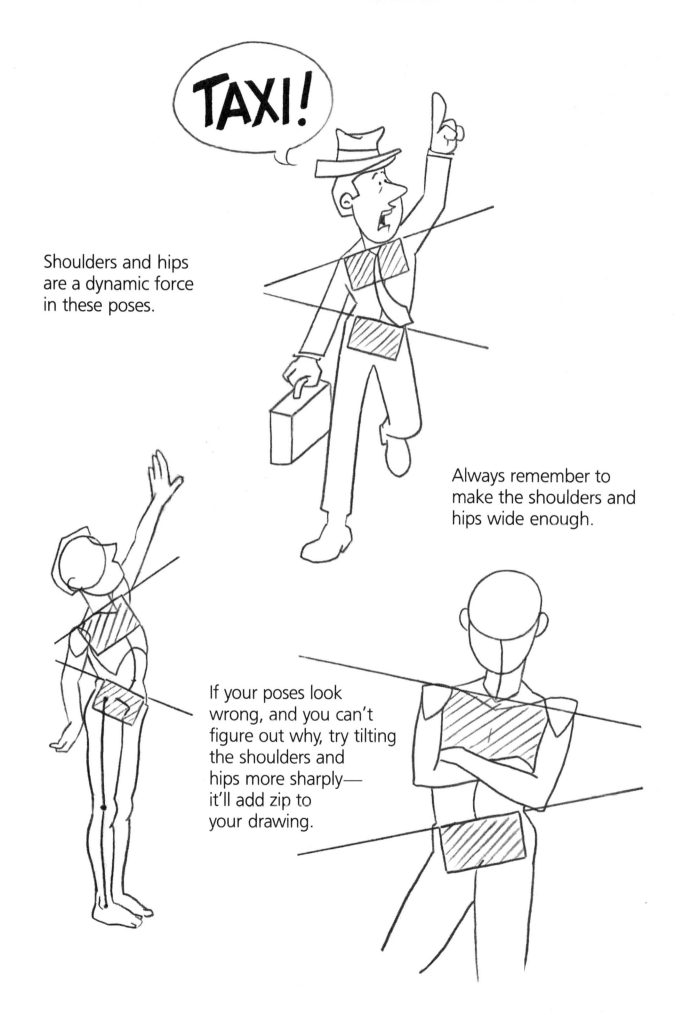

Shoulders and hips are a dynamic force in these poses.

Always remember to make the shoulders and hips wide enough.

If your poses look wrong, and you can't figure out why, try tilting the shoulders and hips more sharply—it'll add zip to your drawing.

Filling Out The Body

In realistic figure drawing, most people are drawn six heads high. But cartoon characters are usually scaled down to four heads. Obviously, you can add heads for a taller character and subtract them for a shorter character.

As we have seen, the torso (here the shaded area) is the center of the body, onto which shoulders, hips, arms, and legs are hinged.

THE CORE CONSTRUCTION OF THE BODY ALWAYS REMAINS THE SAME. YOU BUILD ON TOP OF IT TO ACHIEVE THE SHAPE YOU WANT.

The torso of an overweight individual tends to tilt backward to compensate for the added weight in front.

Unusual Body Constructions

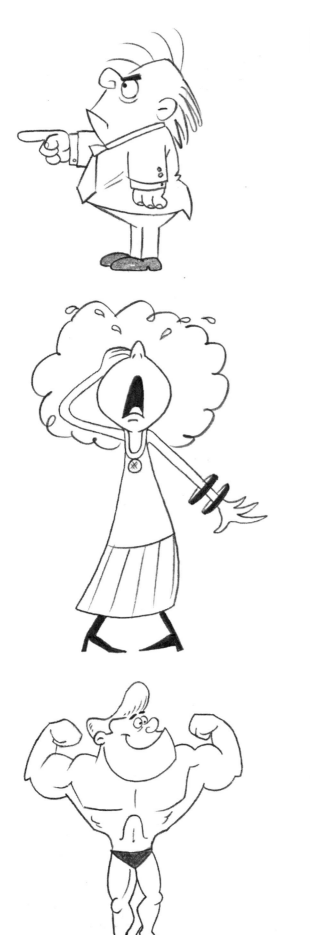

Half moon

As long as you are aware of the basic principles of the torso, hips, and shoulders, you can experiment with body types based on any geometric shape. Make some up yourself. You've heard of a tough guy who's built like a refrigerator? That's a rectangle. Try it!

Narrow triangle

Wide triangle

Practice Body Constructions

Try experimenting with these
constructions. Notice that
the torso, not the arms and
legs, is always the focal
point of the body.

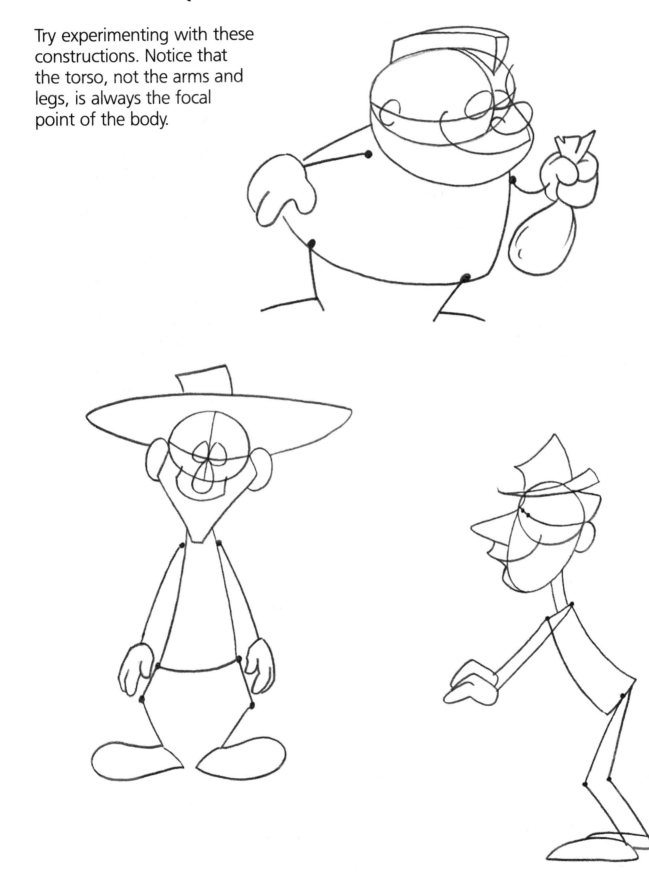

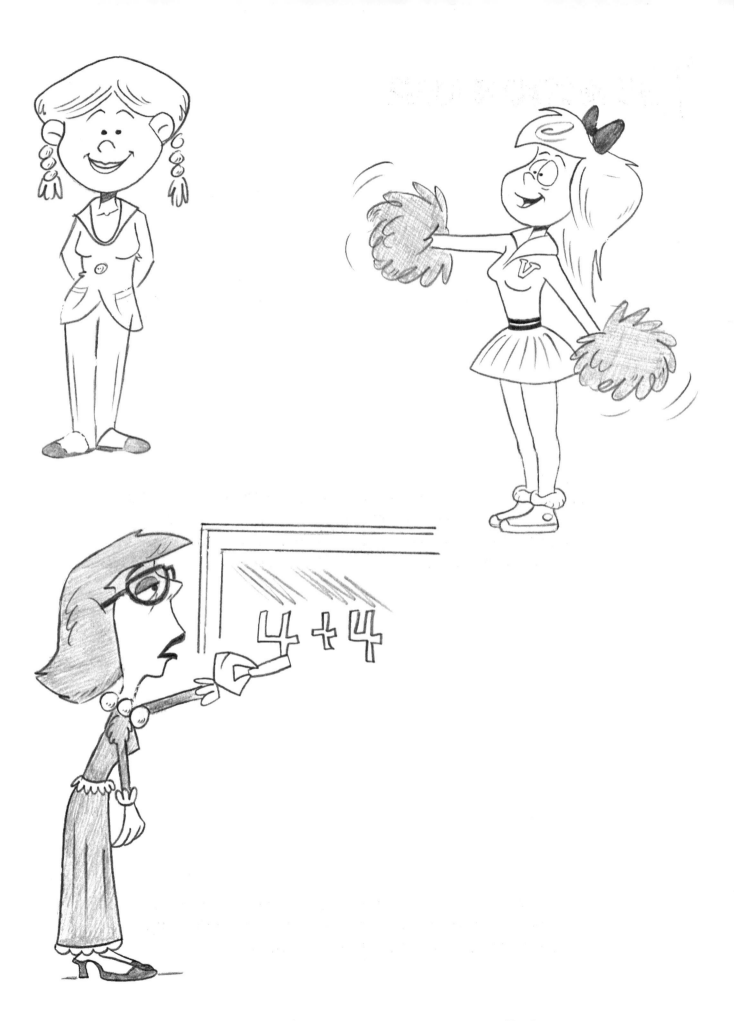

THE ACTION LINE

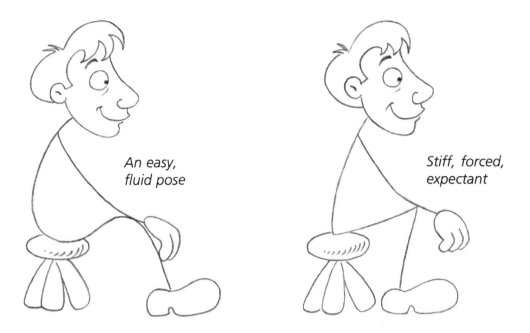

An easy, fluid pose

Stiff, forced, expectant

When the body bends, twists, turns, or is otherwise in motion, a new set of problems is presented to the comic strip artist. The body needs to have a general sweep to it, a graceful flow. This is achieved quite simply with the action line.

The action line follows the natural curve of the spine. Use it to rough out the pose before you start detailing specific body parts, then follow it loosely.

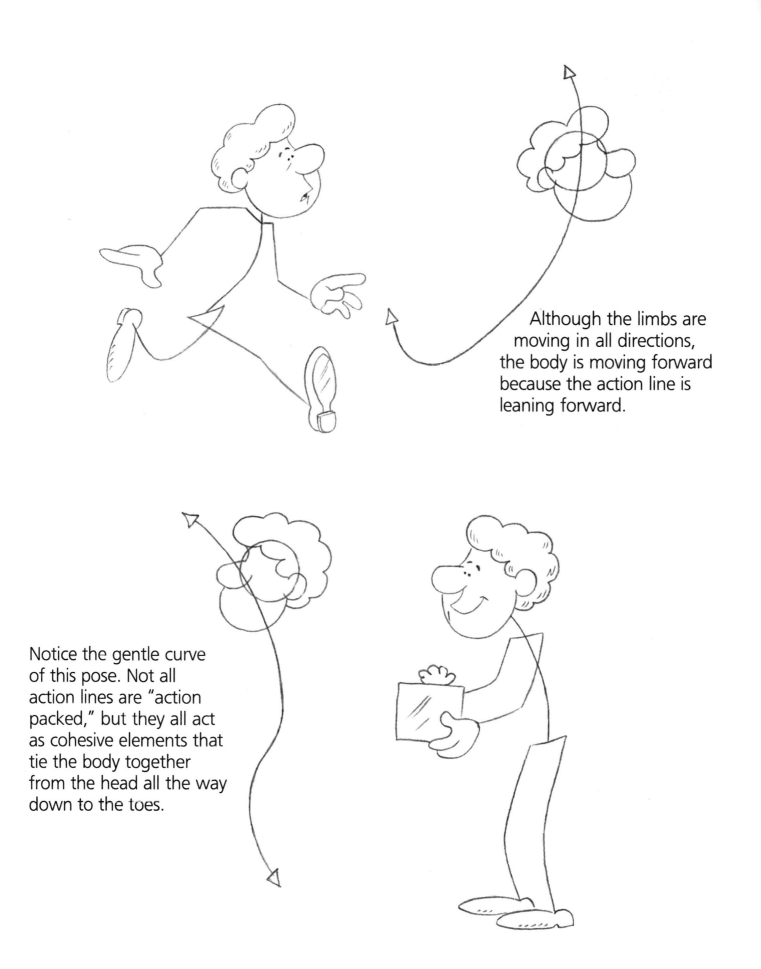

Although the limbs are moving in all directions, the body is moving forward because the action line is leaning forward.

Notice the gentle curve of this pose. Not all action lines are "action packed," but they all act as cohesive elements that tie the body together from the head all the way down to the toes.

Notice the underlying
action lines
in these poses.

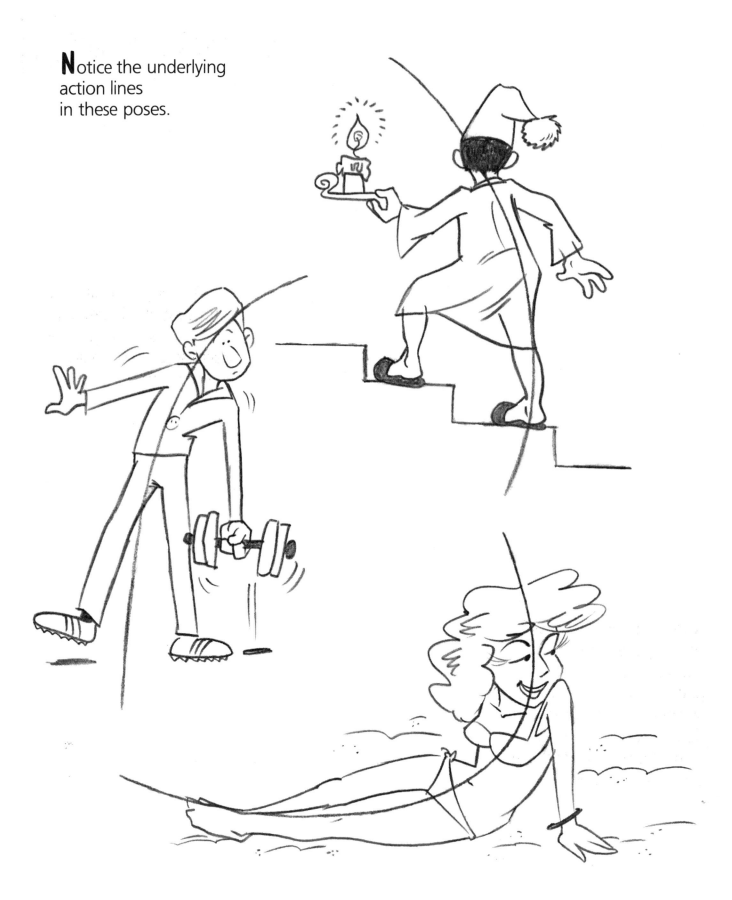

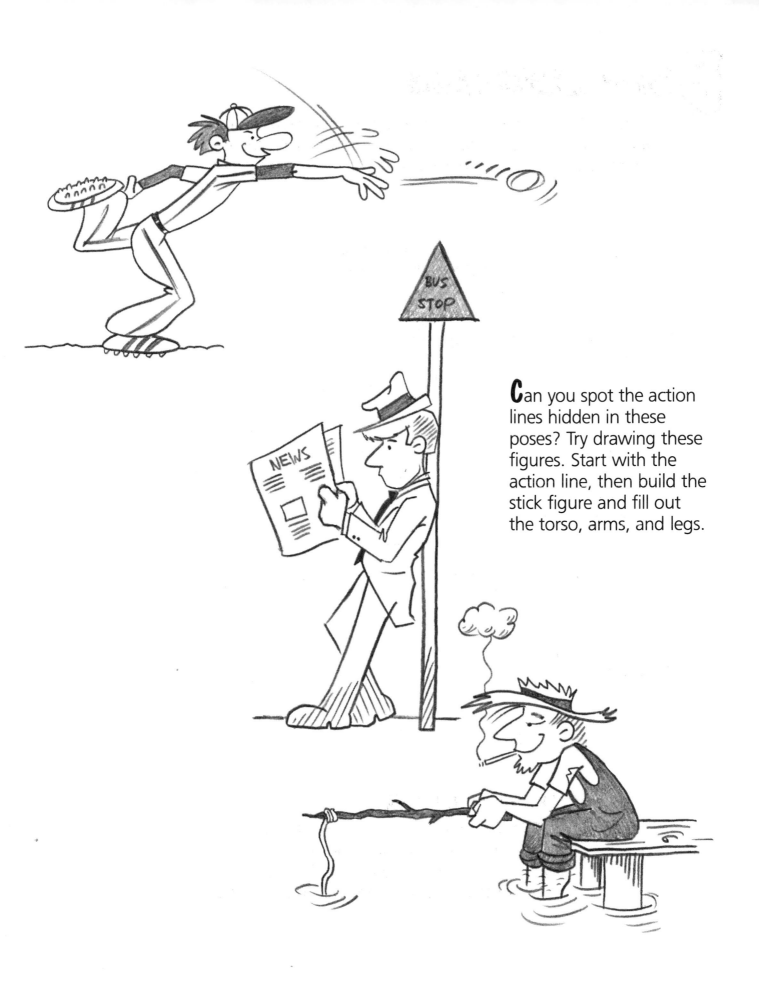

Can you spot the action lines hidden in these poses? Try drawing these figures. Start with the action line, then build the stick figure and fill out the torso, arms, and legs.

BODY LANGUAGE

Some thoughts and feelings are portrayed most clearly by nuances of gesture. The way a particular shoulder is held high, the way the chest sticks out . . . such is the language of the body.

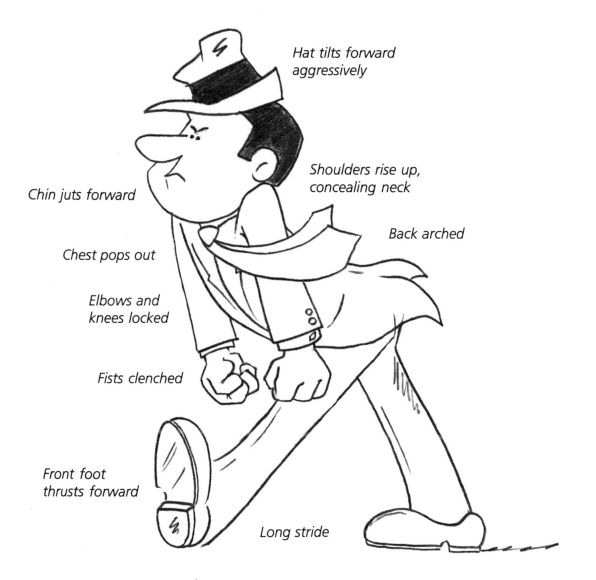

Hat tilts forward aggressively

Shoulders rise up, concealing neck

Chin juts forward

Back arched

Chest pops out

Elbows and knees locked

Fists clenched

Front foot thrusts forward

Long stride

THE "DETERMINED WALK"

The world's most famous comic strip pose . . . This is the one pose every character sooner or later assumes. Every part of this man's body says "determination"—even the tilt of his hat!

Body language doesn't have to be an intricate or elaborate system. These four poses all convey very different moods, yet the only difference between them is that the right arm is positioned differently in each drawing.

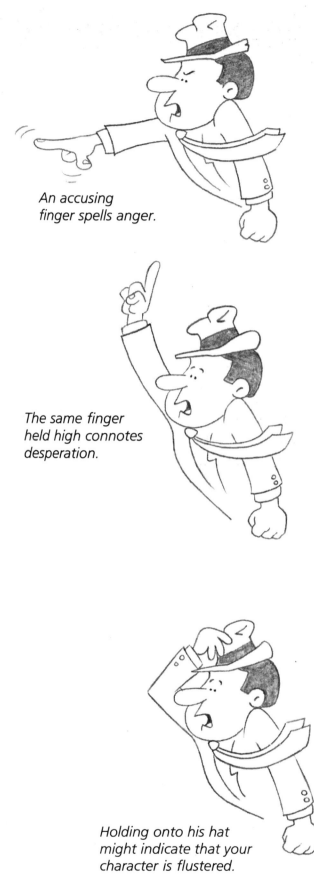

An accusing finger spells anger.

The same finger held high connotes desperation.

Holding onto his hat might indicate that your character is flustered.

The stiff arm and outthrust palm suggest violent action.

Language of the Lower Body

 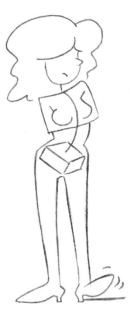 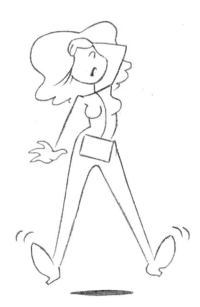

Nervous
Knees together.
Feet point toward
each other.

Impatient
Legs stiff.
One foot "taps."

Shocked
Legs extended.
Feet point outward,
off the ground.

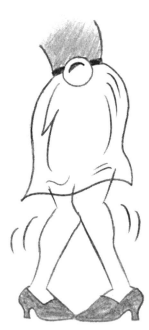 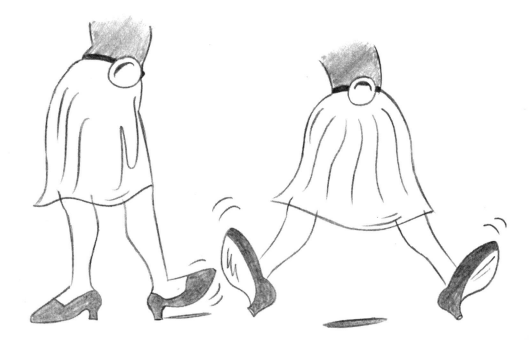

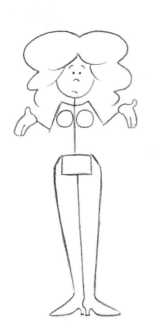

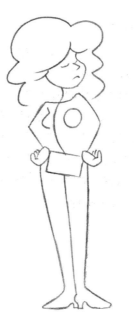

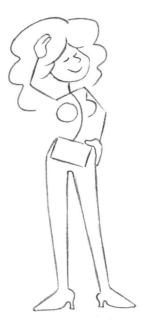

Confused
Palms up,
elbows bent,
shoulders raised.

Indignant
Arms akimbo,
one shoulder raised,
chin held high.
Backs of hands
on hips.

Vain
Shoulder rises
into chin. Primping.
Lots of hip and
shoulder dynamics.

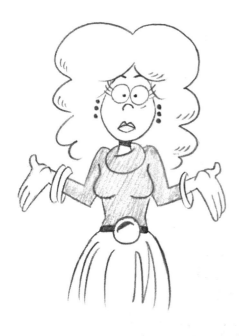

Using the Pose to Express Emotion

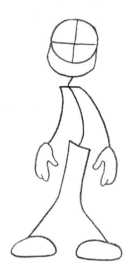

Lovesick
The knees are together, as in the "nervous" pose. Here, however, the arms and shoulders are loose, with the hands flapping at the character's sides. The head is tilted, very unsteady.

Sorrow
The entire body collapses. The arms and shoulders go limp, and the chest caves in. Oddly enough, the chin is held high.

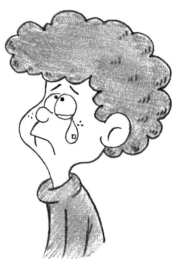

Shame
The chin is tucked into the chest. The head faces down, but the eyes look up. The hands are hidden behind the back, and one foot nervously scratches at the ground.

COMIC STRIP STEREOTYPES

Comic strips all work off stereotypes—the reader has to instantly recognize the personality of the character, so the body has to match the personality. This is important because if you wanted to draw a cute young character, for example, and you drew that character with a skinny body, the drawing probably wouldn't turn out right no matter how many times you tried. This kind of cute character is usually plump. In the next few pages, we'll show you how to draw some comic strip stereotypes that you can use to develop your own characters. As you look at these, be aware of the action line and the body construction.

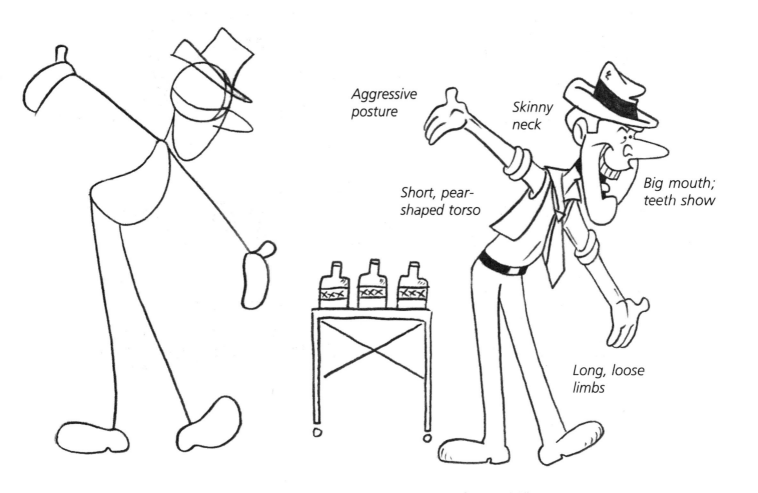

Aggressive posture

Skinny neck

Short, pear-shaped torso

Big mouth; teeth show

Long, loose limbs

The Wise Guy

Also known as the con artist or practical joker. He can be the brunt of a gag, as well as the instigator. Either way, he enters a comic strip panel with loads of energy, always making a big splash.

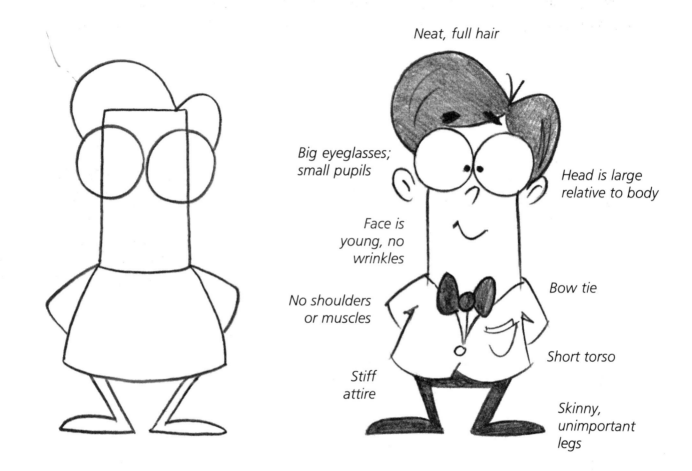

Neat, full hair

Big eyeglasses; small pupils

Head is large relative to body

Face is young, no wrinkles

Bow tie

No shoulders or muscles

Short torso

Stiff attire

Skinny, unimportant legs

The Genius

This soft-spoken character always has the upper hand. Seemingly an innocent, he uses facts and figures like weapons, verbally disarming any bully. But all this comes quite naturally to the genius, who remains unassuming throughout.

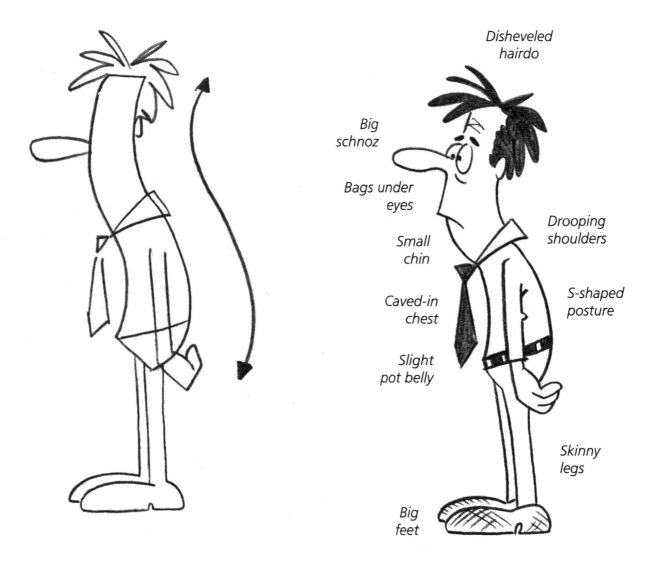

Disheveled hairdo

Big schnoz

Bags under eyes

Small chin

Caved-in chest

Slight pot belly

Big feet

Drooping shoulders

S-shaped posture

Skinny legs

The Wimp

Many comic strips are based on this career victim. The wife nags him. The boss yells at him. His kids don't even respect him. He tries hard, but he just can't get out of his own way. A classic.

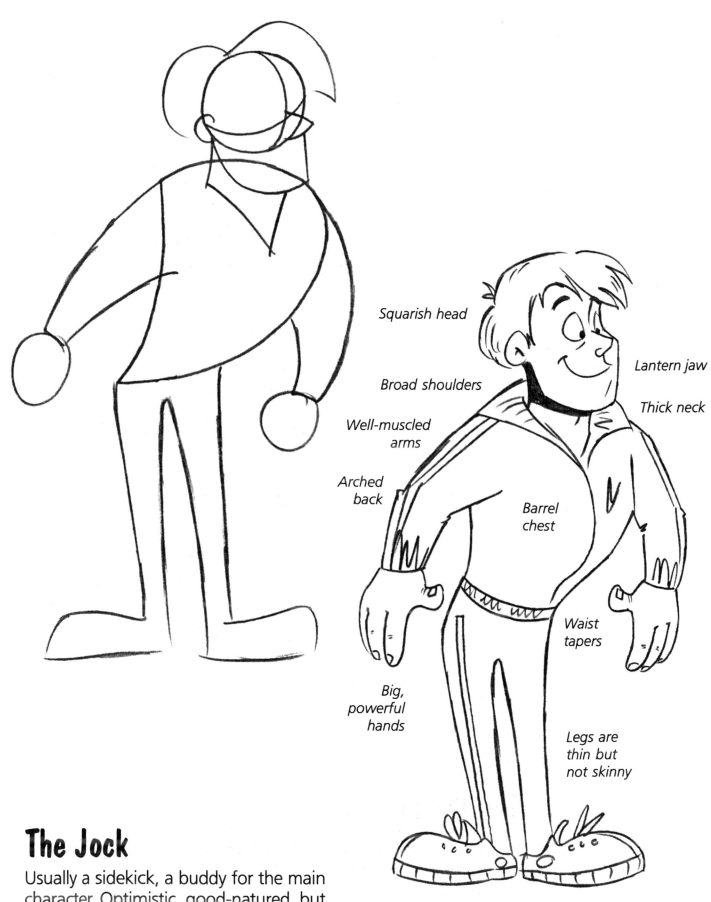

Squarish head

Lantern jaw

Broad shoulders

Thick neck

Well-muscled arms

Barrel chest

Arched back

Waist tapers

Big, powerful hands

Legs are thin but not skinny

The Jock

Usually a sidekick, a buddy for the main character. Optimistic, good-natured, but no rocket scientist. He's at his best when he's being overpowering. Team him up with a wimpy character for big laughs.

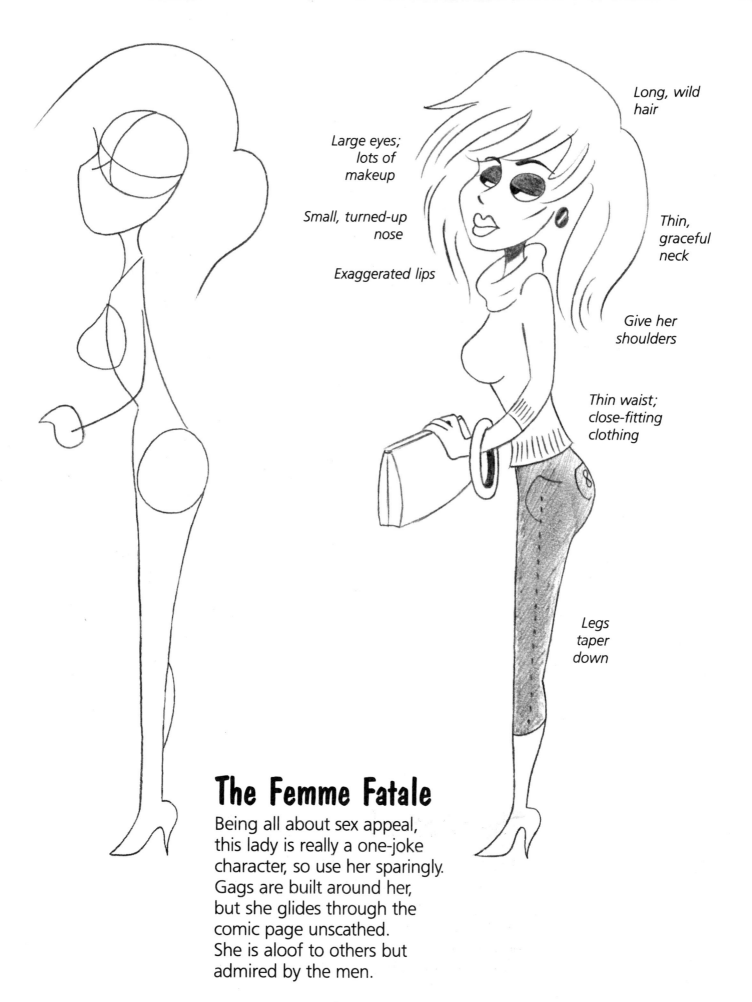

Large eyes;
lots of
makeup

Small, turned-up
nose

Exaggerated lips

Long, wild
hair

Thin,
graceful
neck

Give her
shoulders

Thin waist;
close-fitting
clothing

Legs
taper
down

The Femme Fatale

Being all about sex appeal, this lady is really a one-joke character, so use her sparingly. Gags are built around her, but she glides through the comic page unscathed. She is aloof to others but admired by the men.

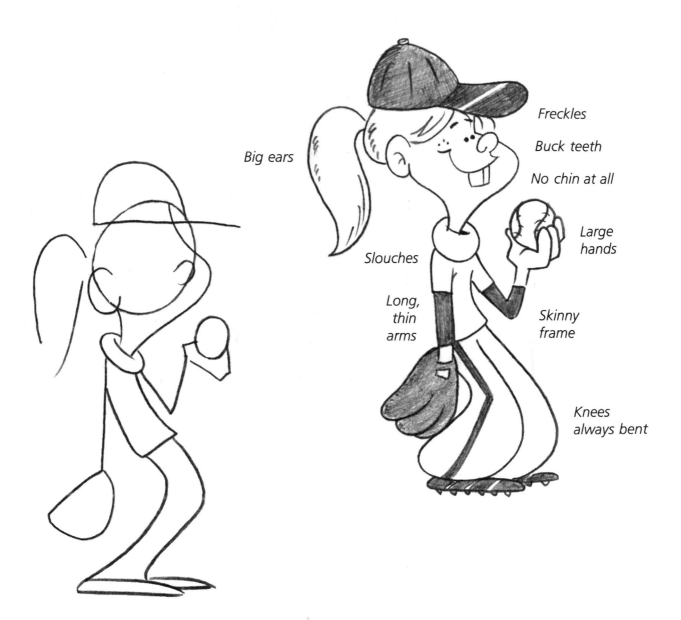

Big ears

Slouches

Long,
thin
arms

Freckles

Buck teeth

No chin at all

Large
hands

Skinny
frame

Knees
always bent

The Goofball

A daffy, ditzy, lovable klutz. Full of good intentions, none of which ever work out. Every chore she undertakes turns into utter chaos, yet she remains unscathed and unaware of the wreckage left in her wake. She can be a very likeable sidekick.

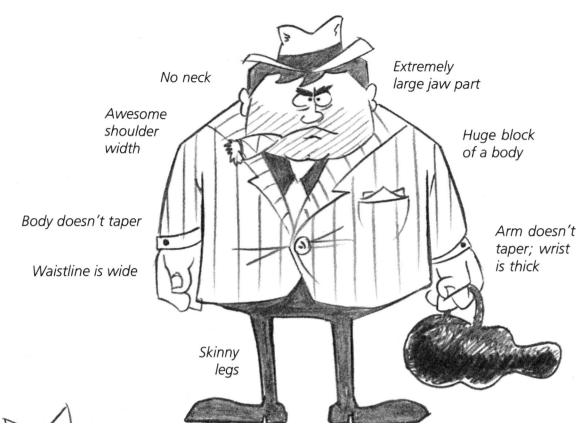

No neck

Awesome
shoulder
width

Extremely
large jaw part

Huge block
of a body

Body doesn't taper

Arm doesn't
taper; wrist
is thick

Waistline is wide

Skinny
legs

The Bully

Mean through and through. Physically
intimidating. Gloats when he wins;
cries when he loses. The bully *dislikes*
the main character. He plots against
the hero—and often wins.

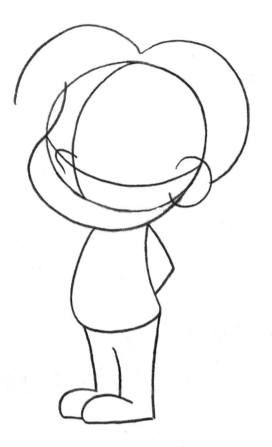

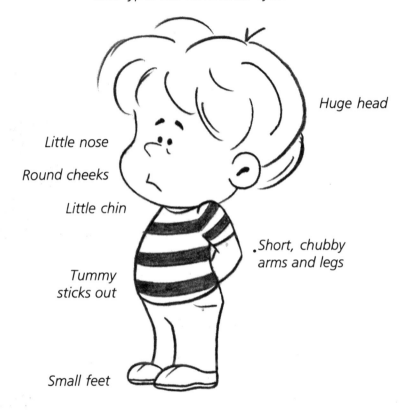

Contrary to popular belief, cute types can have small eyes.

Huge head

Little nose

Round cheeks

Little chin

.Short, chubby arms and legs

Tummy sticks out

Small feet

The Cute Type

This stereotype is innocent and often insecure.
He doesn't deliver wisecracks but, rather,
offers unique observations that are
usually humorous and always sincere.
This is an immensely popular character type.

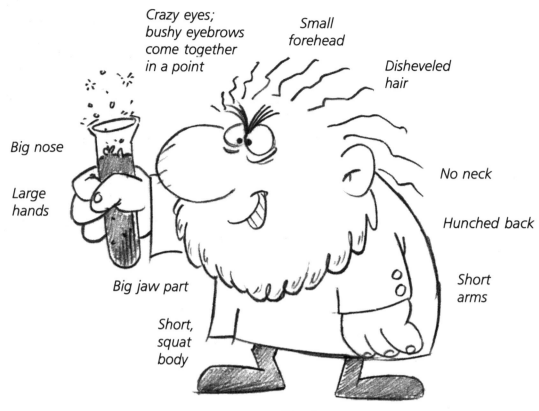

Crazy eyes; bushy eyebrows come together in a point

Small forehead

Disheveled hair

Big nose

No neck

Large hands

Hunched back

Big jaw part

Short arms

Short, squat body

Tiny legs

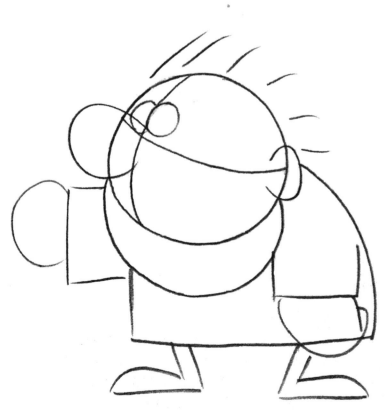

The Mad Scientist

Diabolical and evil. Usually a short, stubby character with an oversized head. Unlike the bully, the villain is usually unsuccessful in his attempts to confound the hero. His schemes often backfire, and he becomes the victim of his own doings. A very versatile and popular character.

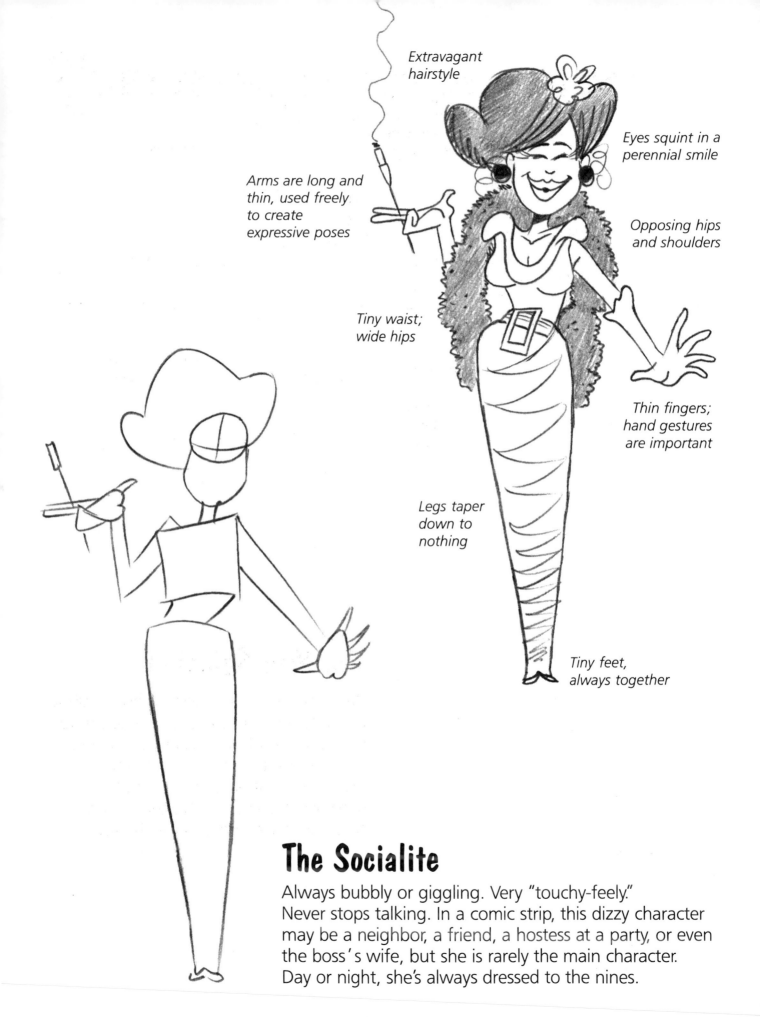

Extravagant
hairstyle

Eyes squint in a
perennial smile

Arms are long and
thin, used freely
to create
expressive poses

Opposing hips
and shoulders

Tiny waist;
wide hips

Thin fingers;
hand gestures
are important

Legs taper
down to
nothing

Tiny feet,
always together

The Socialite

Always bubbly or giggling. Very "touchy-feely."
Never stops talking. In a comic strip, this dizzy character
may be a neighbor, a friend, a hostess at a party, or even
the boss's wife, but she is rarely the main character.
Day or night, she's always dressed to the nines.

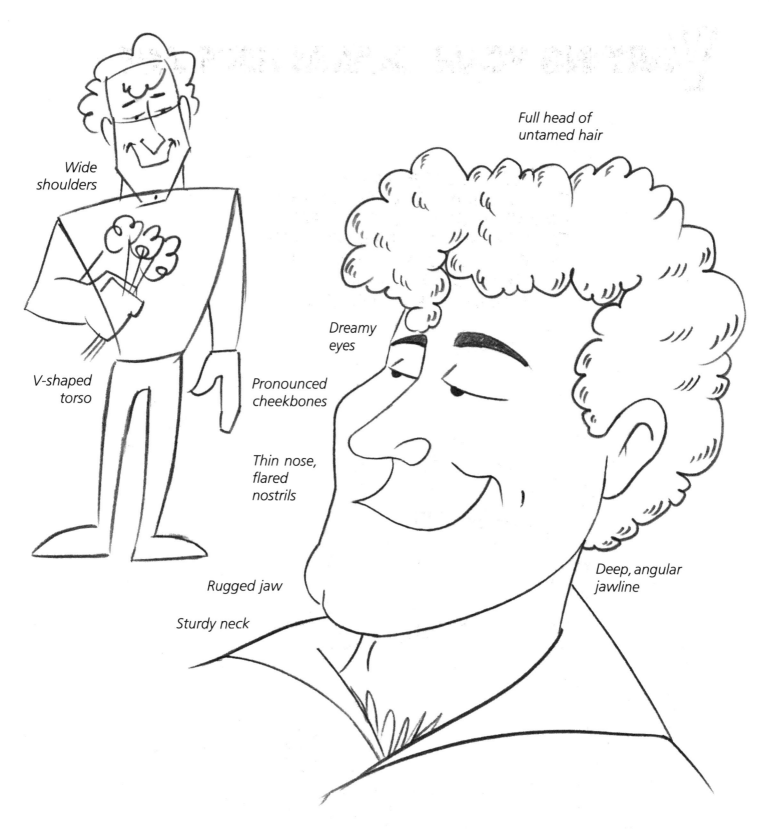

Wide shoulders

V-shaped torso

Full head of untamed hair

Dreamy eyes

Pronounced cheekbones

Thin nose, flared nostrils

Rugged jaw

Sturdy neck

Deep, angular jawline

The Leading Man

This Casanova is vain, shallow, and constantly on the make. Sometimes he's a chronic liar. He's usually a supporting character, used for comic relief. His vanity is more often than not unsubstantiated by his effect on women.

VARYING YOUR CHARACTER'S AGE

NOW LET'S TAKE ONE CHARACTER THROUGH SEVERAL STAGES OF LIFE TO SEE WHAT EFFECT TIME HAS ON BODY LANGUAGE, GESTURES, AND FACIAL FEATURES...

This is JIMMY, 9 years old. . . .

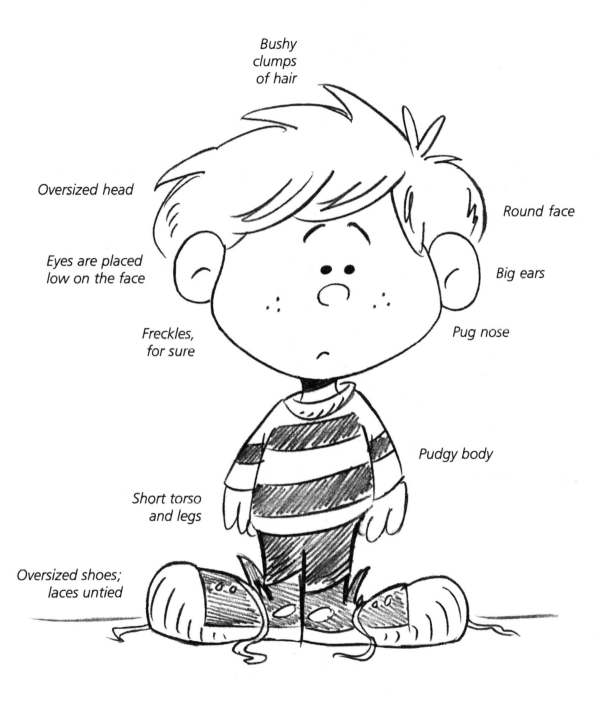

Bushy
clumps
of hair

Oversized head

Round face

Eyes are placed
low on the face

Big ears

Freckles,
for sure

Pug nose

Pudgy body

Short torso
and legs

Oversized shoes;
laces untied

. . . And at 16 years of age, here's JIM

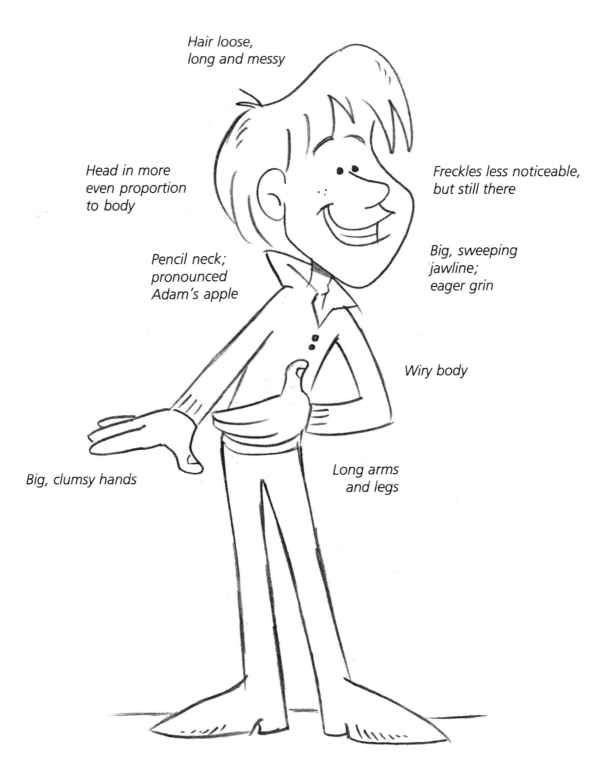

Hair loose,
long and messy

Head in more
even proportion
to body

Freckles less noticeable,
but still there

Pencil neck;
pronounced
Adam's apple

Big, sweeping
jawline;
eager grin

Wiry body

Big, clumsy hands

Long arms
and legs

. . . married, with two kids, here's JAMES

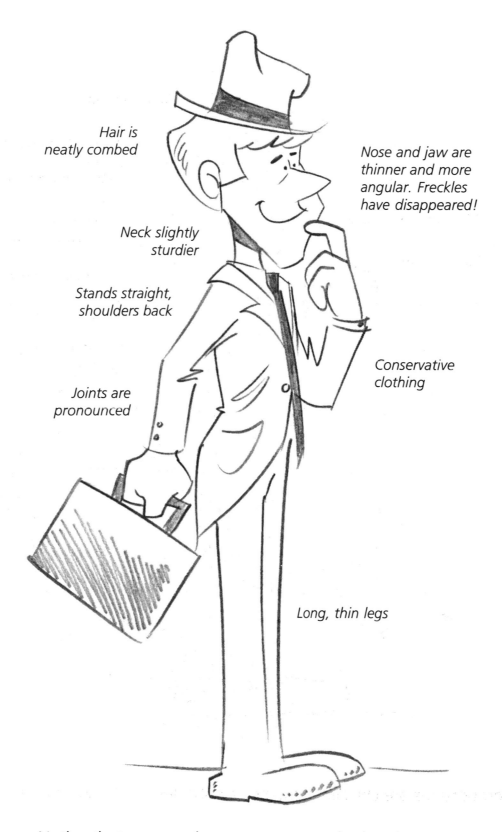

Hair is neatly combed

Nose and jaw are thinner and more angular. Freckles have disappeared!

Neck slightly sturdier

Stands straight, shoulders back

Conservative clothing

Joints are pronounced

Long, thin legs

Notice that as your character matures, the head gets smaller and the body gets longer and thinner.

And, at 80, here is GRANDPA JIMMY

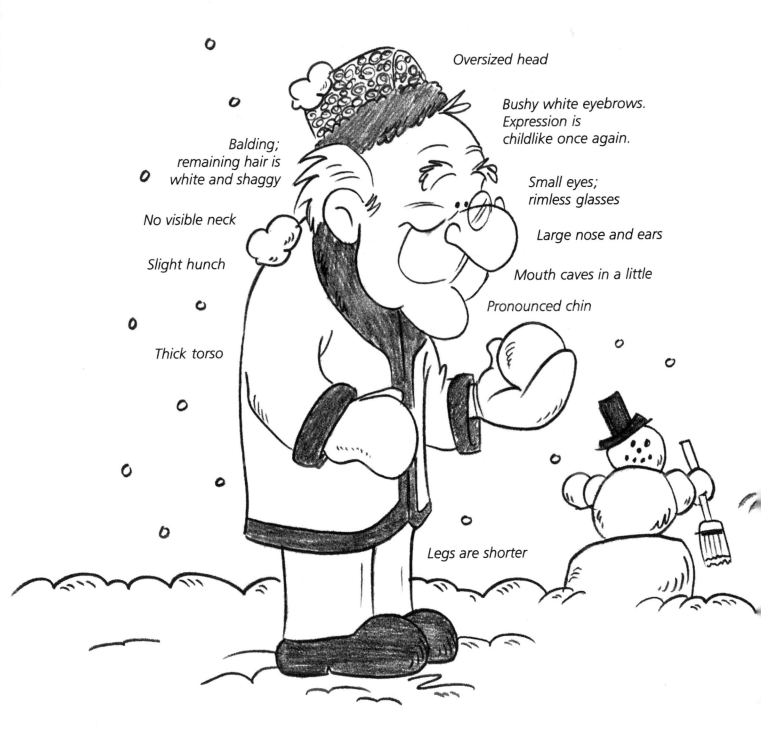

Oversized head

Bushy white eyebrows. Expression is childlike once again.

Balding; remaining hair is white and shaggy

No visible neck

Slight hunch

Thick torso

Small eyes; rimless glasses

Large nose and ears

Mouth caves in a little

Pronounced chin

Legs are shorter

His proportions are childlike—the body is shorter and thicker, the head larger.

RAWING ANIMALS

Human Skull/Jaw Configuration

ANIMALS—tough to draw? Relax—they're easy to do. Animals can be more fun to draw than people, and they are extremely popular with comic strip readers. Best of all, there are a multitude of species to choose from.

All animal heads have the same two basic elements: skull and jaw. Unlike humans, however, animals have jaws that shoot straight out from the skull, roughly parallel to the floor.

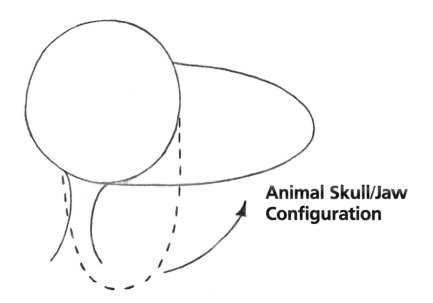

Animal Skull/Jaw Configuration

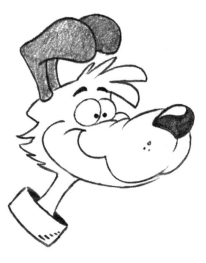

Dogs

Basic Head Construction

Start by drawing the basic skull/jaw combination.

Draw axis lines, eyes, and nose.

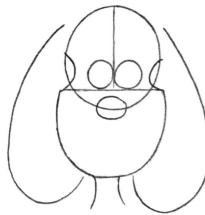

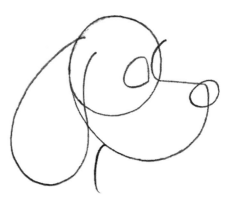

Indicate the proper slope of the forehead. Add the ears and neck.

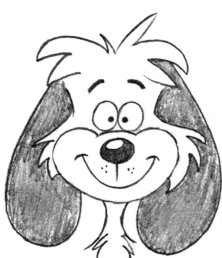

Now fluff up the fur! Widen the cheeks to accommodate the width of the smile, and add shading and details.

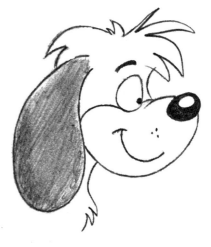

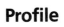

Front View

Profile

Getting Nosey

Of all animals, dogs have perhaps the greatest variety of nose types. Obviously, the size of the nose is determined by the size of the dog, but the shape is largely a matter of personal preference. Don't forget the whiskers!

Smiling Dogs

An animal's snout is attached directly to his mouth, so his smile is different from a human's. Basically, there are three types of smiles for animals; all are defined by placement of the mouth.

Normal
The mouth starts in the crease of the cheek, slopes downward, and ends abruptly; it is not joined to the snout.

Zany
The mouth is drawn from the tip of the nose and swings all the way back into the cheek. The lower lip stays short, however.

Subdued
This small mouth "floats" in the middle of the face; it is closer to the snout.

The Saint Bernard

A proud but good-natured character, the Saint Bernard is big, gentle, and goofy.

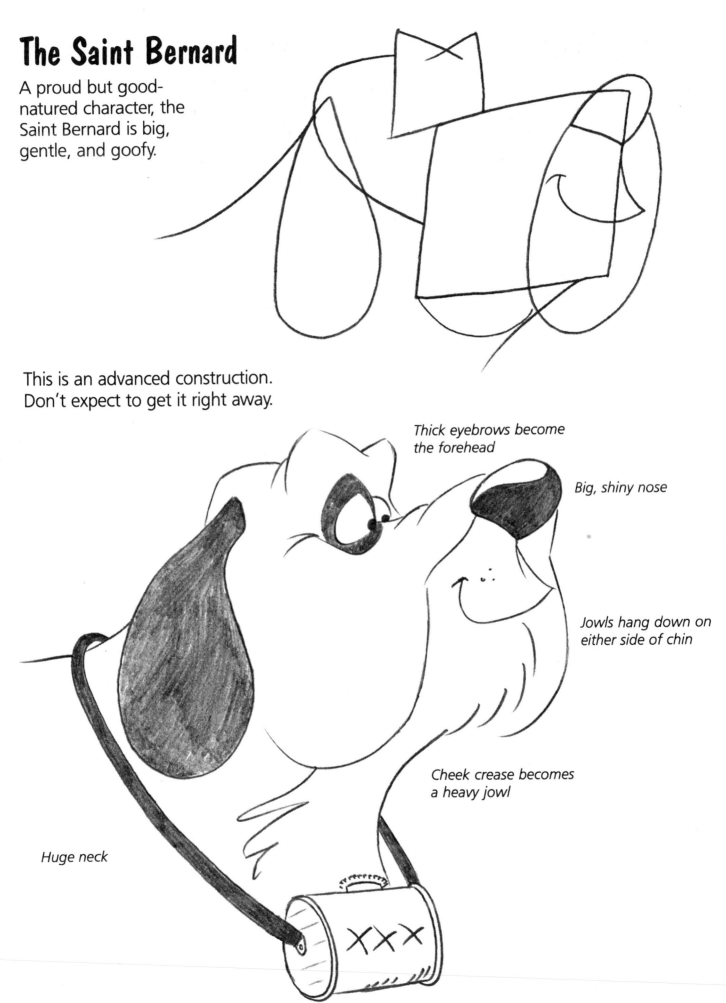

This is an advanced construction. Don't expect to get it right away.

Thick eyebrows become the forehead

Big, shiny nose

Jowls hang down on either side of chin

Cheek crease becomes a heavy jowl

Huge neck

Sheepdog

A sheepdog appears to be just a mound of floppy fur, but under-neath is a solid construction on which the character is built. Remember—never show a sheepdog's eyes!

Small skull

Large jaw

No chin, but lower lip protrudes

Puppy

The elements that make this character so adorable are his oversized, square head, small mouth, and large eyes.

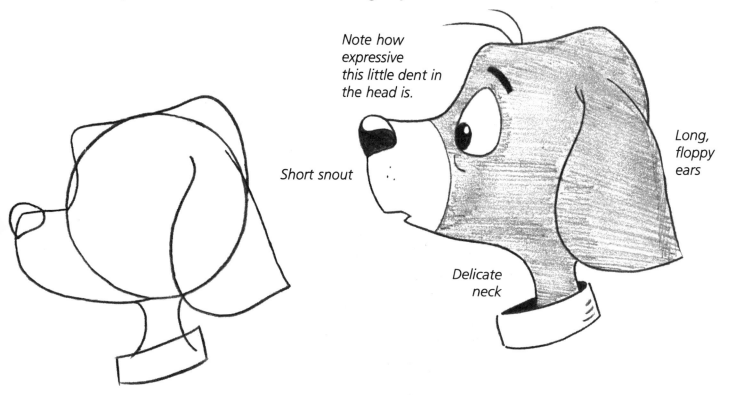

Note how expressive this little dent in the head is.

Short snout

Long, floppy ears

Delicate neck

Practice Constructions

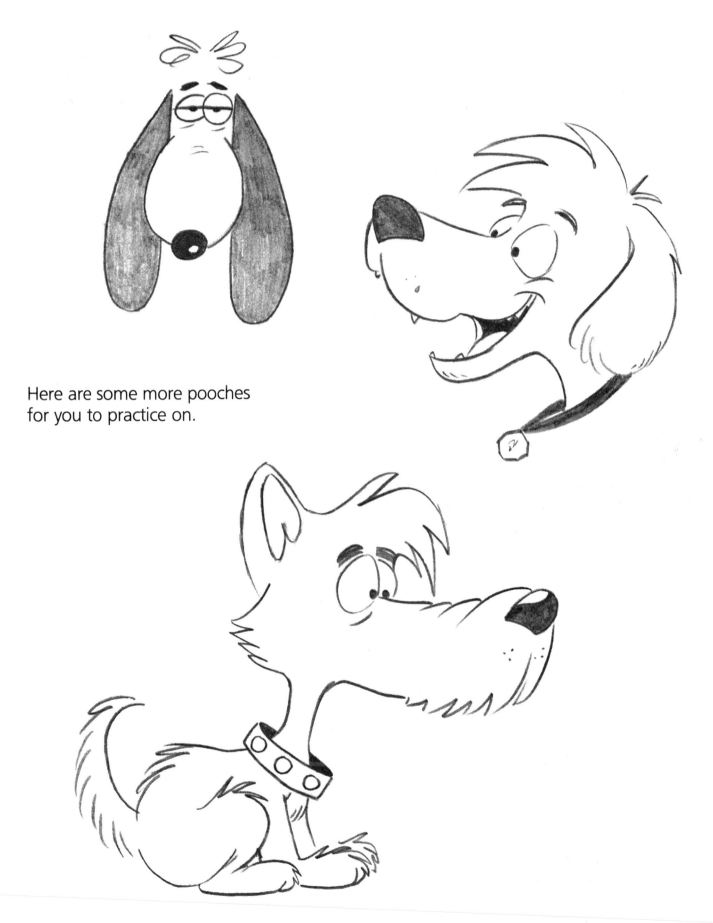

Here are some more pooches
for you to practice on.

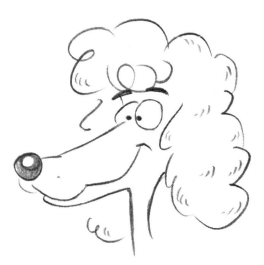
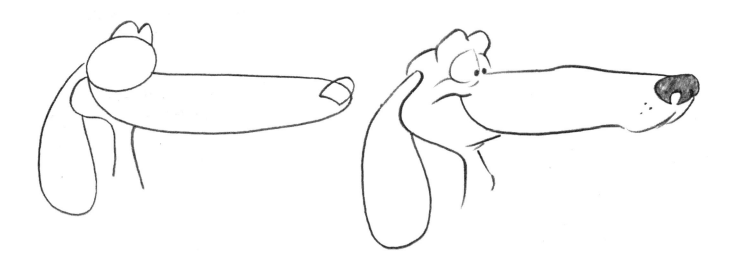

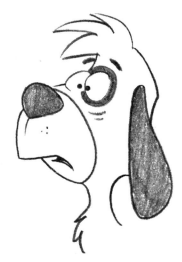

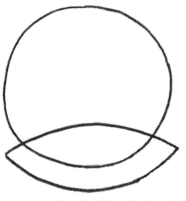

Draw the skull and cheek.

Basic Head Construction

Cats are hard to draw because of their unusual head construction. They have wide cheeks, small mouths, and virtually no jaws. Therefore, we have to create a new facial section—the "cheek part." Instead of using the standard jaw, we widen the cheeks, and they become the lower half of the head. The cheek part lacks the sharp angles of a jawline. The mouth is placed inside the cheek part, and so is the snout.

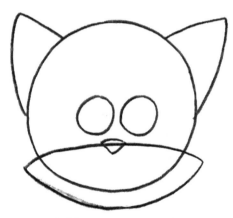

Add eyes, ears, and a tiny triangular nose.

The fur line above the eyes doubles as eyebrows.

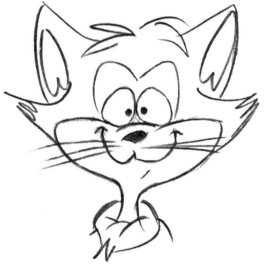

The Finished Feline!

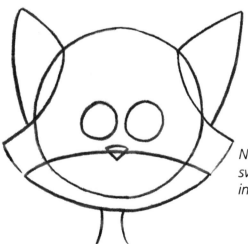

Give the forehead a long sweep and draw in the neck.

Notice how the sweeping forehead turns into part of the cheek.

Don't forget to practice drawing the profile. Once you've mastered this standard cat's head, drawing the following constructions of special pussy cats should be a piece of cake.

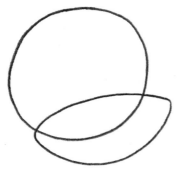

Start with the skull and cheek part.

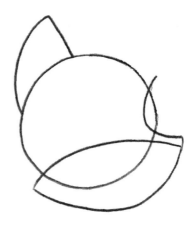

Add the slope of the forehead, which leads into the bridge of the nose. Place the ear on top of the head.

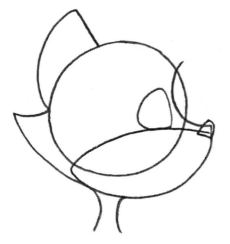

Add the nose, eyes, and neck.

Ruffle some fur off of the cheek. Polish up your drawing.

Kitten

Cute? Yes. Innocent? No! A kitten, no matter how cuddly, is still a mischief-maker.

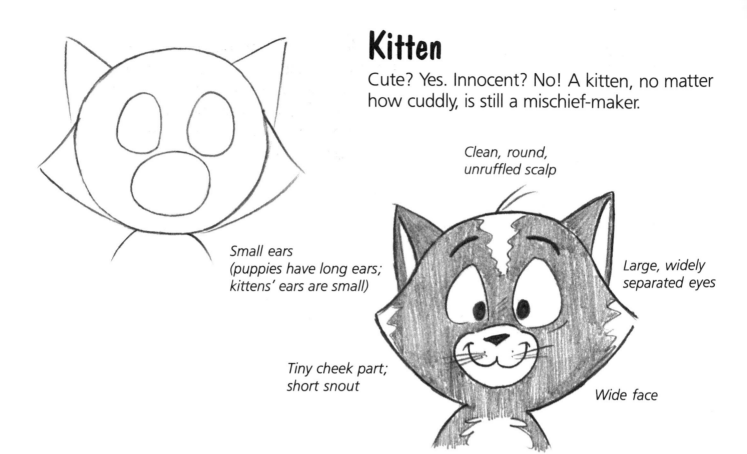

Clean, round, unruffled scalp

Small ears (puppies have long ears; kittens' ears are small)

Large, widely separated eyes

Tiny cheek part; short snout

Wide face

Street Cat

The wise guy of comic strip cats. A scavenger and practical joker.

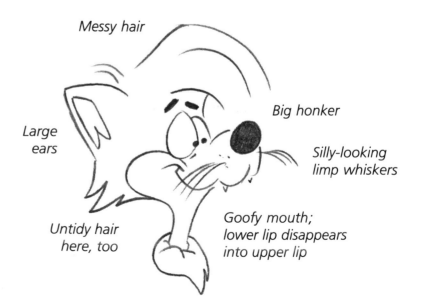

Messy hair

Big honker

Large ears

Silly-looking limp whiskers

Untidy hair here, too

Goofy mouth; lower lip disappears into upper lip

Fat Cat

Chow time! The only thing
larger than the belly of this
character is his appetite.
His huge cheeks are accen-
tuated by a small snout
and tiny ears. No neck for
this plump pussy.

Sex Kitten

Prrr! What a charmer.
She's the star of the cat show.
She has more delicate features
than the other cats, and a real
hairdo—not just fur.

BIRDS OF A FEATHER

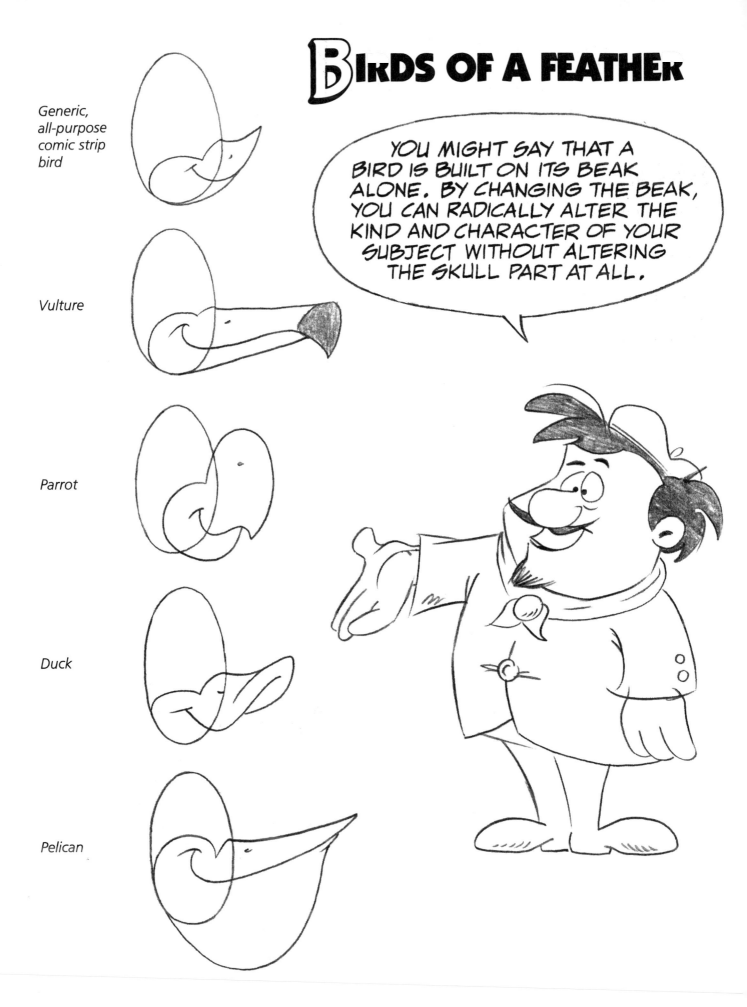

Generic, all-purpose comic strip bird

Vulture

Parrot

Duck

Pelican

YOU MIGHT SAY THAT A BIRD IS BUILT ON ITS BEAK ALONE. BY CHANGING THE BEAK, YOU CAN RADICALLY ALTER THE KIND AND CHARACTER OF YOUR SUBJECT WITHOUT ALTERING THE SKULL PART AT ALL.

Basic Head Construction

The crow is a classic comic strip character. Beaks are interchangeable, but the steps remain the same.

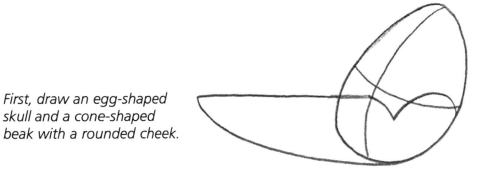

First, draw an egg-shaped skull and a cone-shaped beak with a rounded cheek.

Add big, overlapping eyes that sink into the bridge of the beak. Draw a spindly neck.

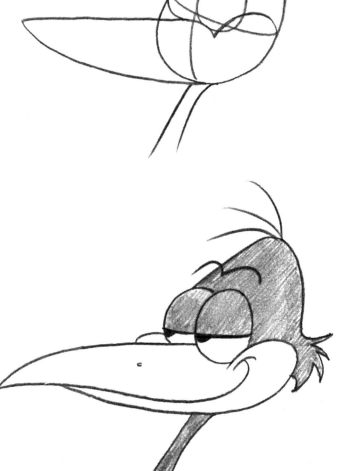

Finishing Touches: Hook the top of the beak over the lower portion. Add a nostril. Fluff the feathers off the cheek, and ruffle those on the top of the head.

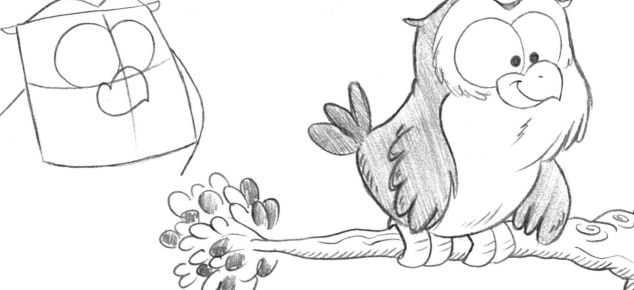

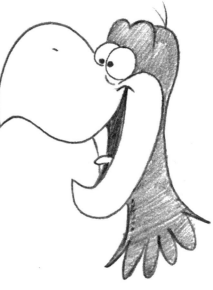

The Owl

The owl has a rectangular head that makes up half of his body. This husky bird has big eyes and a small beak. The owl is usually wise, often old, and sometimes disgruntled.

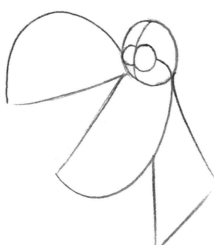

The Parrot

The parrot has a tiny skull, huge, bulbous beak, and smooth head. The tongue is tiny and the eyes are small and round. Unlike most birds, this character gets a chin. The parrot is usually cast as a wise guy, an annoying pest, or a mimic.

Baby Chicken Hawk

This is a hungry, eager-to-learn young predator.

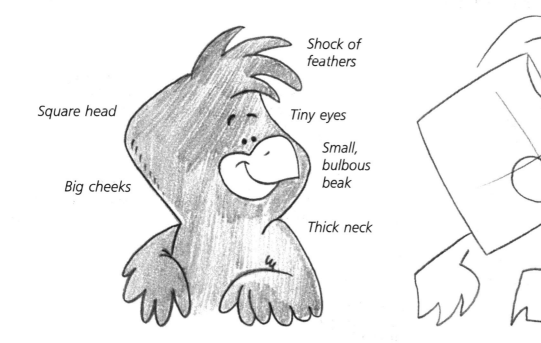

Square head

Shock of feathers

Tiny eyes

Small, bulbous beak

Big cheeks

Thick neck

Eagle

The eagle is often cast as a military type. Think of a boot camp sergeant.

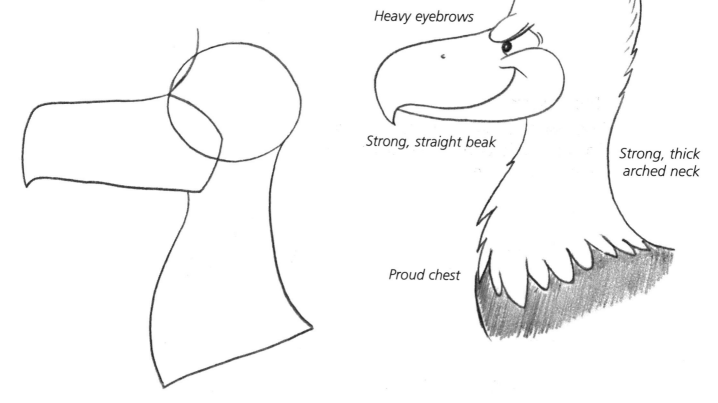

Aggressively sloped forehead

Heavy eyebrows

Strong, straight beak

Strong, thick arched neck

Proud chest

The Stork

The stork has only one function in comic strips—to deliver babies. Sure, it's corny, but people still love it.

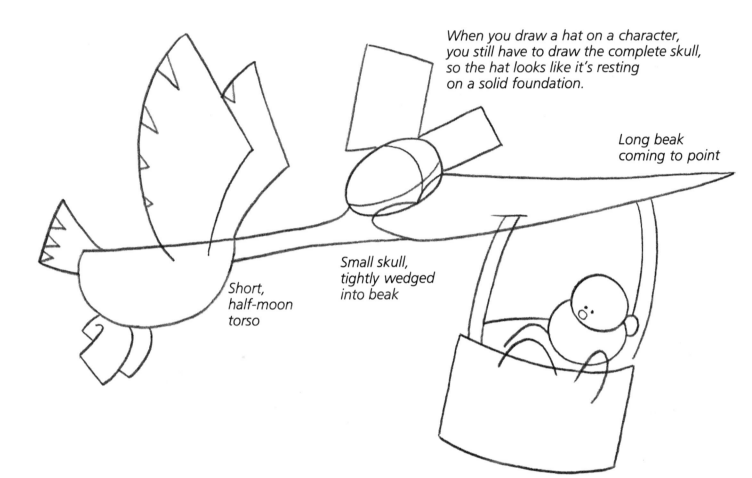

When you draw a hat on a character, you still have to draw the complete skull, so the hat looks like it's resting on a solid foundation.

Long beak coming to point

Small skull, tightly wedged into beak

Short, half-moon torso

The Pelican

The pelican is built just like the stork. The only difference is the pouchlike chin used to store fish.

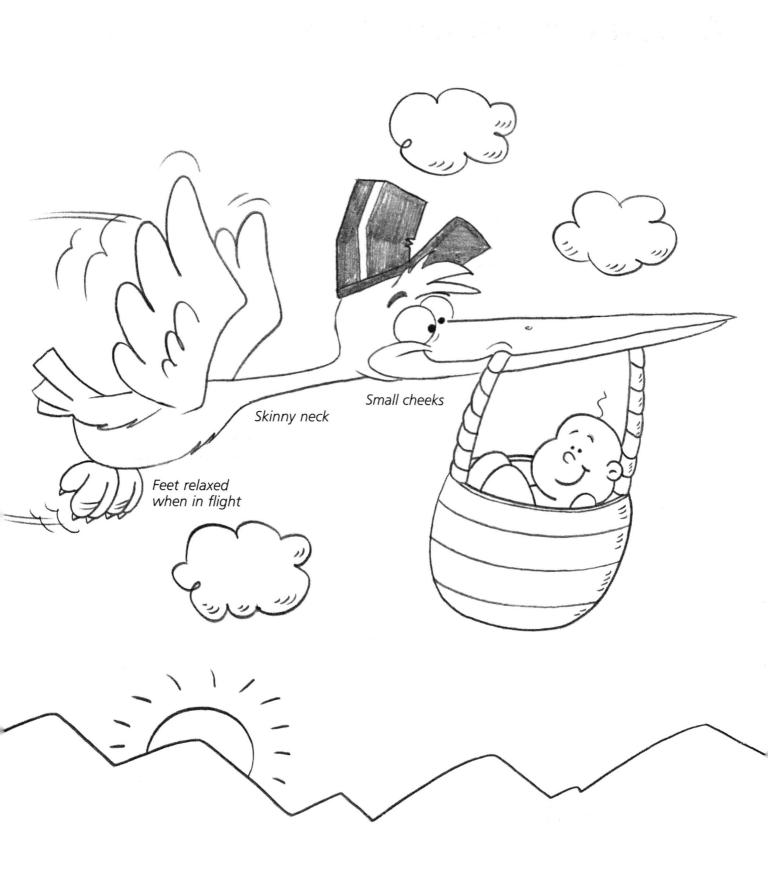

Skinny neck

Small cheeks

Feet relaxed when in flight

When you're drawing birds, feel free to take great liberties with the beak. Like a dog's nose, a bird's beak is his trademark.

A look at some other types of birds

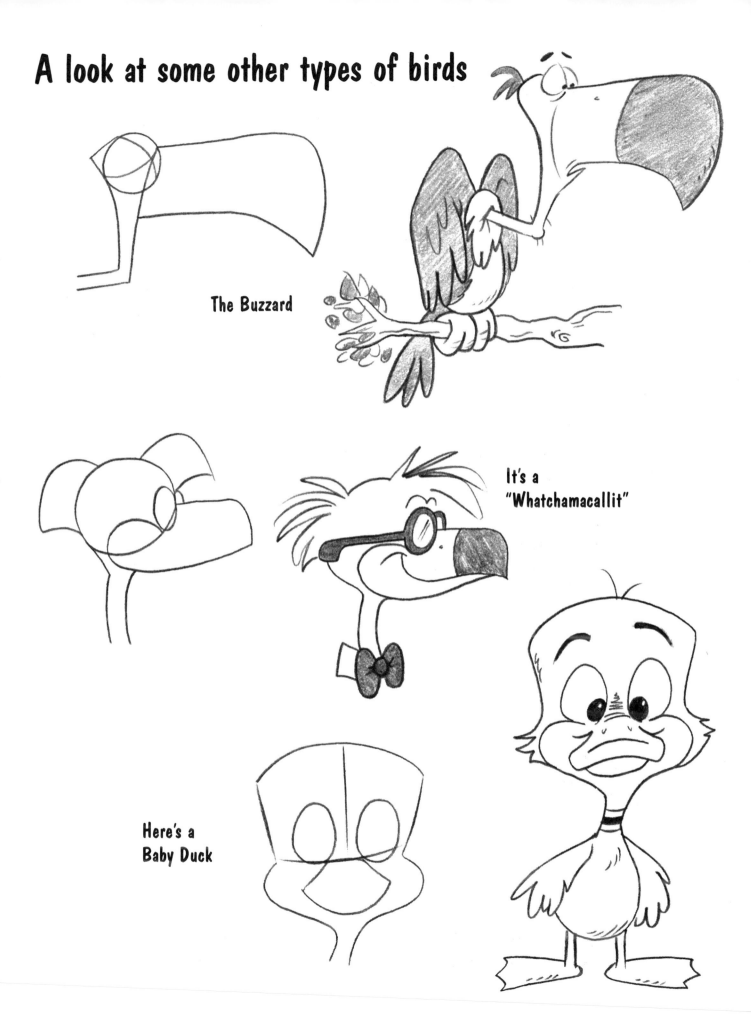

The Buzzard

It's a
"Whatchamacallit"

Here's a
Baby Duck

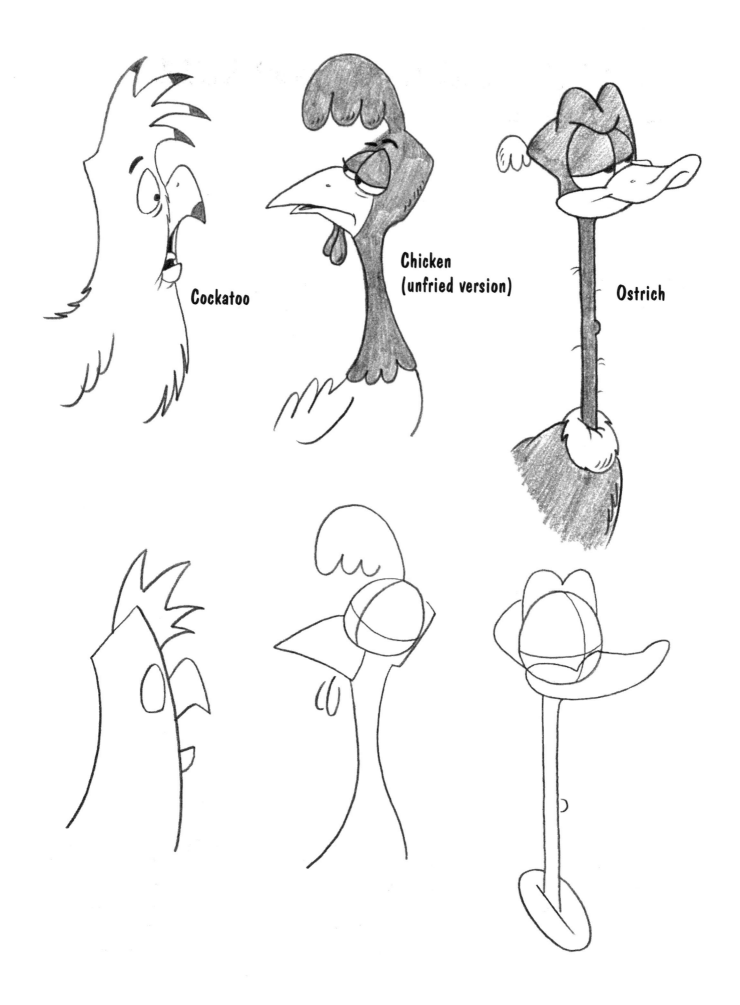

Cockatoo

Chicken
(unfried version)

Ostrich

How to Anthropomorphize Animals

A dog that talks, as do most comic strip dogs, needs to stand upright. But don't just tilt him on his hind legs, or he'll look weird.

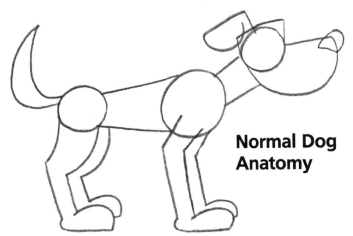

Normal Dog Anatomy

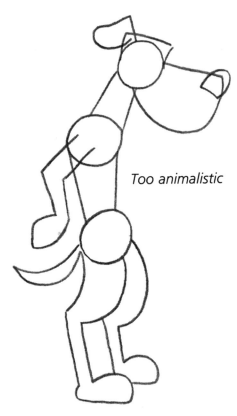

Too animalistic

Too human

The perfect compromise

This creepy canine simply won't do. If he's going to stand upright, he has to have some human characteristics to be believable.

Whoa! I said "some," not "all." This unfortunate fellow has lost too much of his doggy personality. He looks like a Wall Street banker in a dog suit.

Just right. A short, squat characterization of otherwise human anatomy makes this thick, round subject a perfect blend of man and beast.

Building Blocks

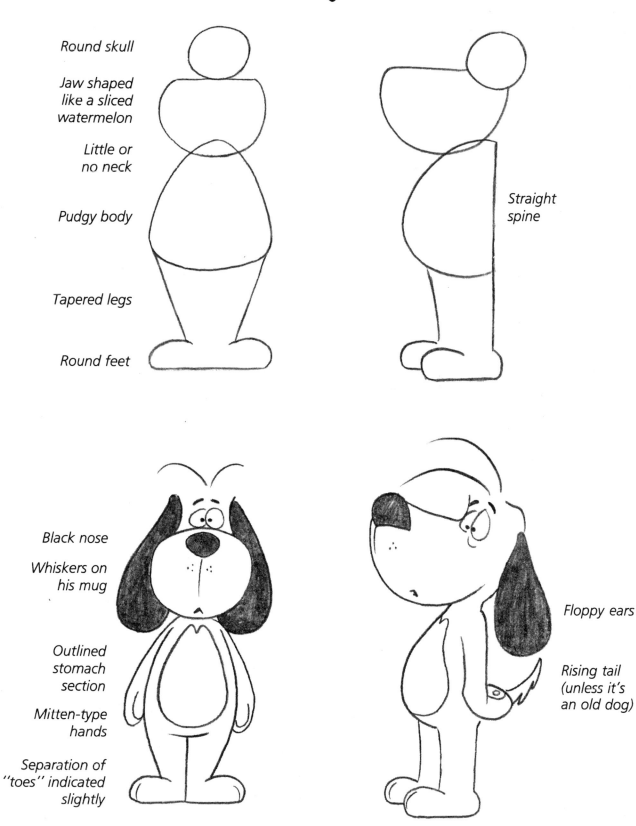

Round skull

Jaw shaped like a sliced watermelon

Little or no neck

Pudgy body

Tapered legs

Round feet

Straight spine

Black nose

Whiskers on his mug

Outlined stomach section

Mitten-type hands

Separation of "toes" indicated slightly

Floppy ears

Rising tail (unless it's an old dog)

Dog vs. Man

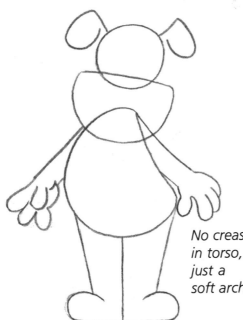

No crease in torso, just a soft arch

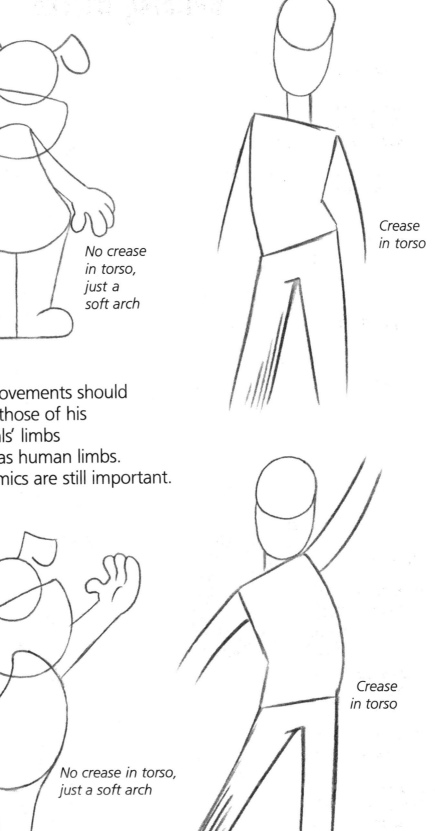

Crease in torso

Your comic strip animal's movements should seem more restricted than those of his human counterpart. Animals' limbs are not as loose and lanky as human limbs. But shoulder and hip dynamics are still important.

No crease in torso, just a soft arch

Crease in torso

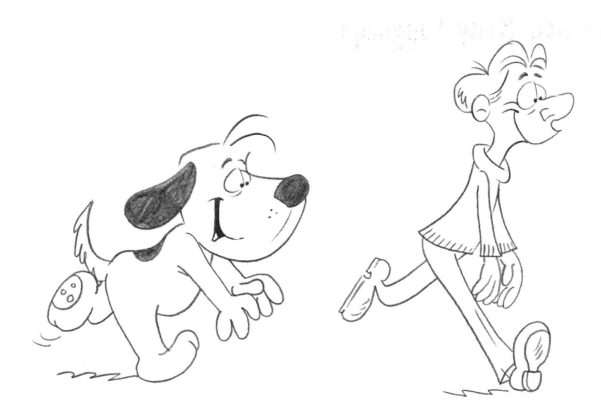

Whereas a human's body curves and then slopes off into straight lines, a "bipedalized" dog's body never straightens out. His body goes from curve to curve, giving him a cute, "squeezable" appearance.

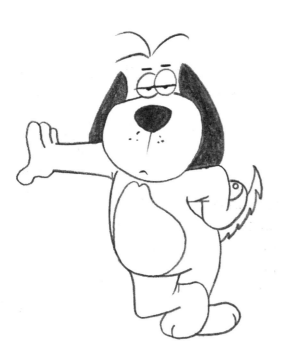

Posture and Body Language

Torsos of standing animals vary in size and shape.
The heavier the torso, the wider the legs
are spread to support the figure's weight.

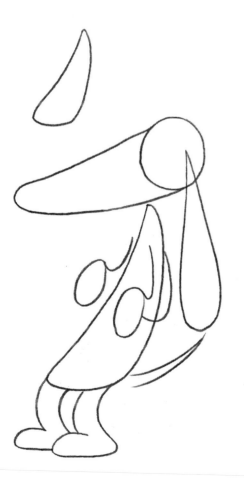

If the torso is long
and skinny, put some
action in the pose
by leaning your
character forward
or, as in this case,
backward.

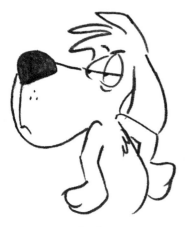

Indignant

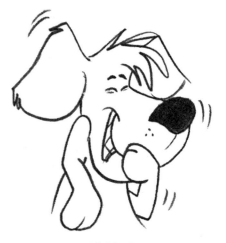

Tickled

Note the difference a little shoulder movement makes in these drawings.

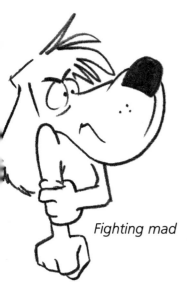

Fighting mad

Dead tired

Ebullient

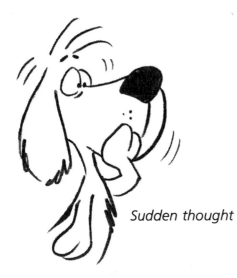

Sudden thought

Caught in the act!

The Anthropomorphized Cat

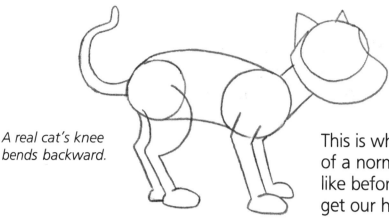

A real cat's knee bends backward.

This is what the anatomy of a normal housecat looks like before we cartoonists get our hands on it.

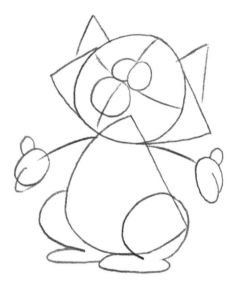

Unlike a cartoon dog, the cartoon cat can retain its catlike hind legs; only the upper body must be humanized. It is perfectly acceptable to humanize the hind legs as well, however.

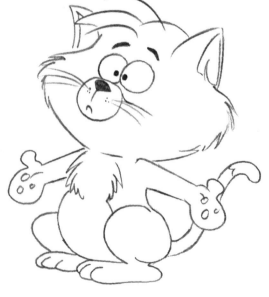

The arms function just like human arms, only with paws instead of hands.

Although this character appears to be standing up, he is really sitting on his hind legs, like a real cat.

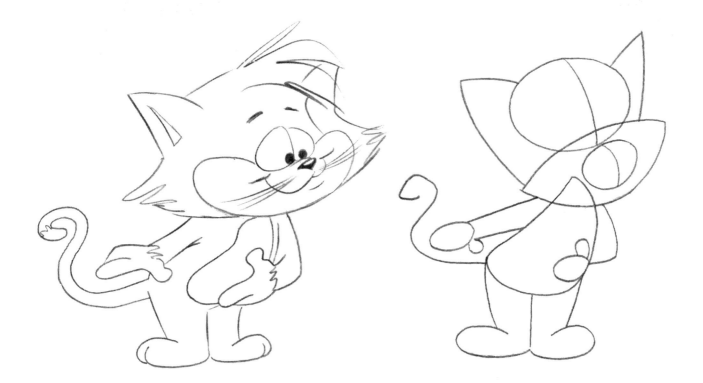

Here are a couple of cats who
stand on their hind legs.

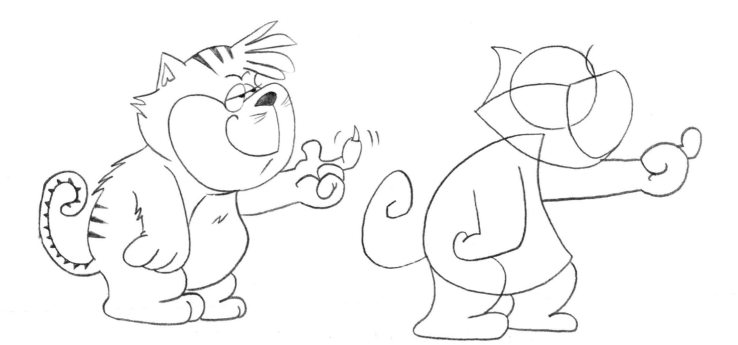

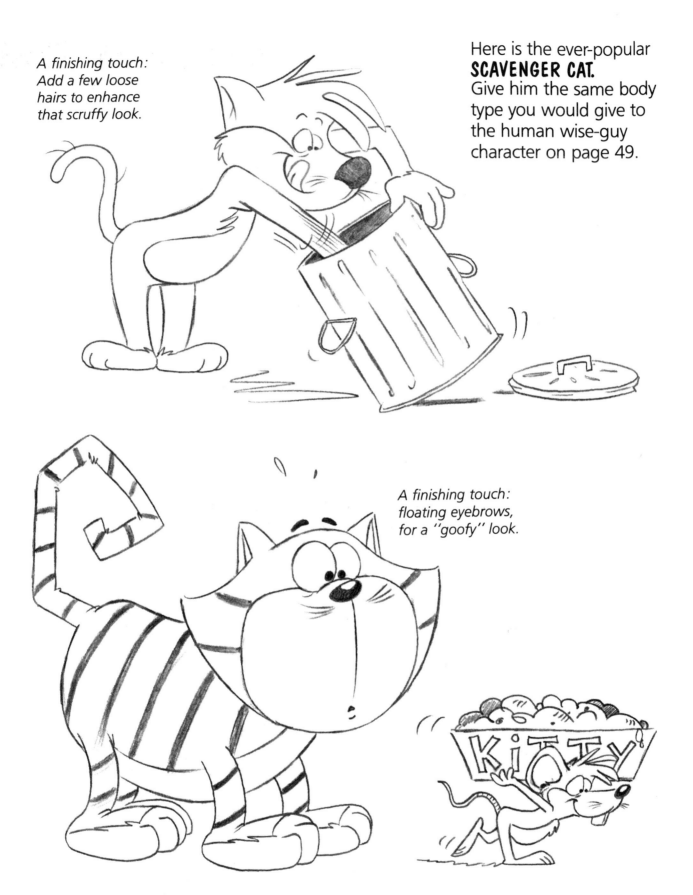

A finishing touch: Add a few loose hairs to enhance that scruffy look.

Here is the ever-popular **SCAVENGER CAT.** Give him the same body type you would give to the human wise-guy character on page 49.

A finishing touch: floating eyebrows, for a "goofy" look.

KITTY

Even when you draw a cartoon cat on all fours, you must adjust the anatomy to prevent your character from appearing too much like a real animal. This is done by removing the cat's knee and elbow joints, thereby making his limbs rubbery.

A Body for the Birds!

Here's your basic, everyday duck.

Wings are folded up and tucked away

Neck slopes into the chest without an obvious separation

Legs are short to the point of being barely noticeable

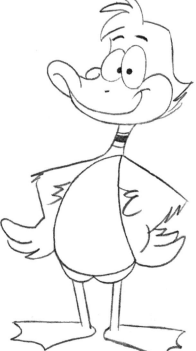

The upright duck possesses these human qualities:

- neck/chest separation
- longer legs
- longer arms, with prominent elbow joints
- bigger head than that of a real duck
- indication of thigh muscles

Bird Hands

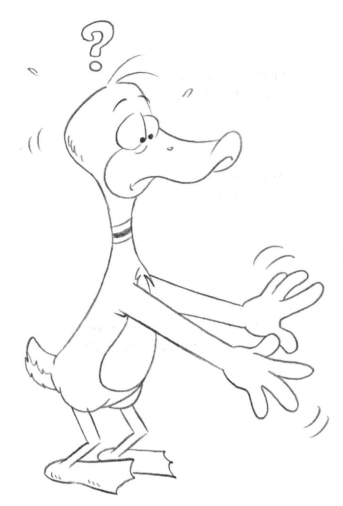

You can put human hands on many cartoon animals, but not on birds. Instead, you must transform the bird's feathers into a subtle suggestion of fingers. Putting hands on a bird would be as incongruous as making hands out of a horse's hooves or a dolphin's fins. Bird anatomy is just too different from that of humans to make literal interchanges feasible.

You have to carefully establish a fine definition between fingers and feathers. These feathers, or fingers, work because this ambiguity is stated successfully.

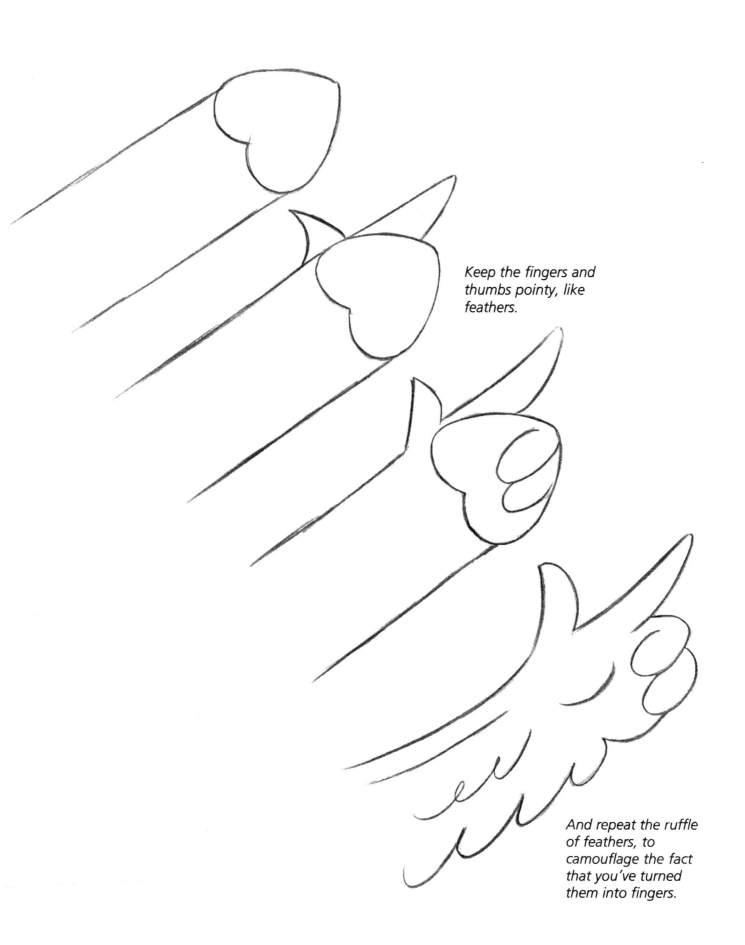

Keep the fingers and thumbs pointy, like feathers.

And repeat the ruffle of feathers, to camouflage the fact that you've turned them into fingers.

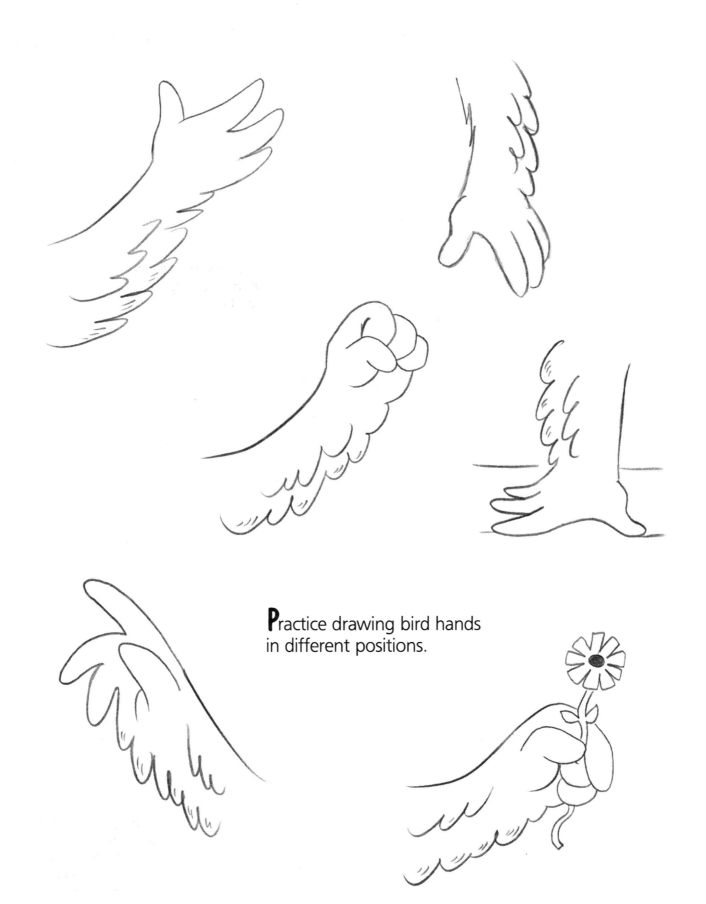

Practice drawing bird hands in different positions.

Personalities and Body Constructions

This spry little pipsqueak is a real gadfly. He has some markings that make him unique: The tip of his beak is colored, as are his feather tips. Also, his pupils have a double circle. (If you want to go one step further, you could color in the tips of his tail feathers as well.)

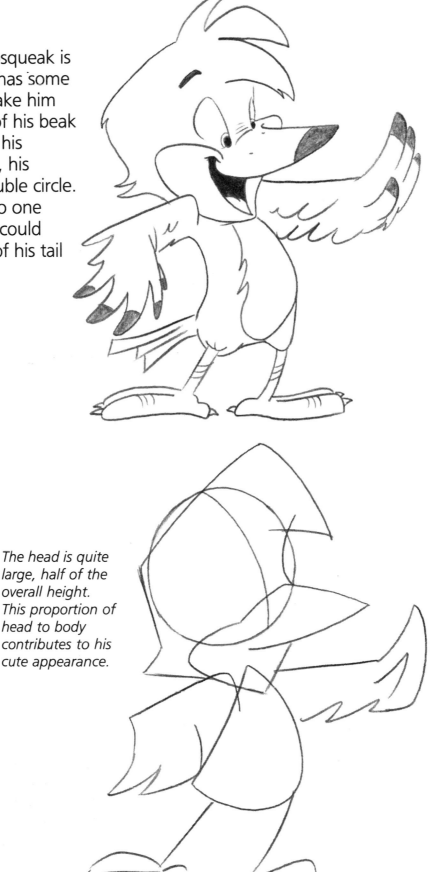

The head is quite large, half of the overall height. This proportion of head to body contributes to his cute appearance.

Anthropomorphosis is not the exclusive domain of the body. See how a piece of clothing (in this case a hat) and a few small props—cigarette and gun—can illustrate a character's personality better than any pose could.

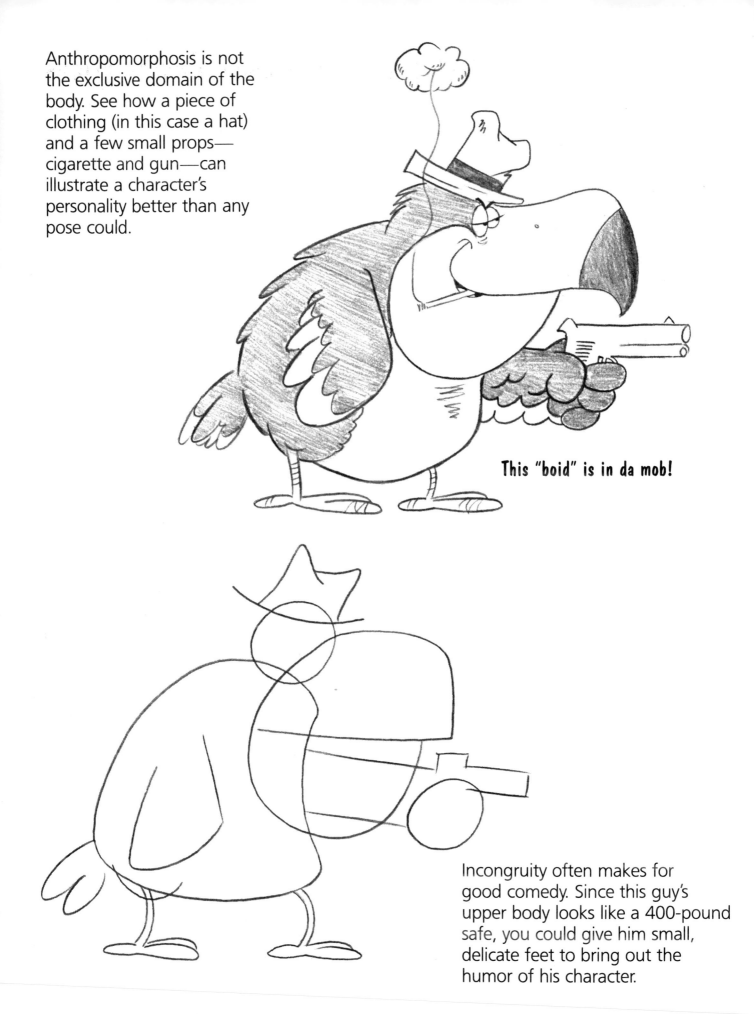

This "boid" is in da mob!

Incongruity often makes for good comedy. Since this guy's upper body looks like a 400-pound safe, you could give him small, delicate feet to bring out the humor of his character.

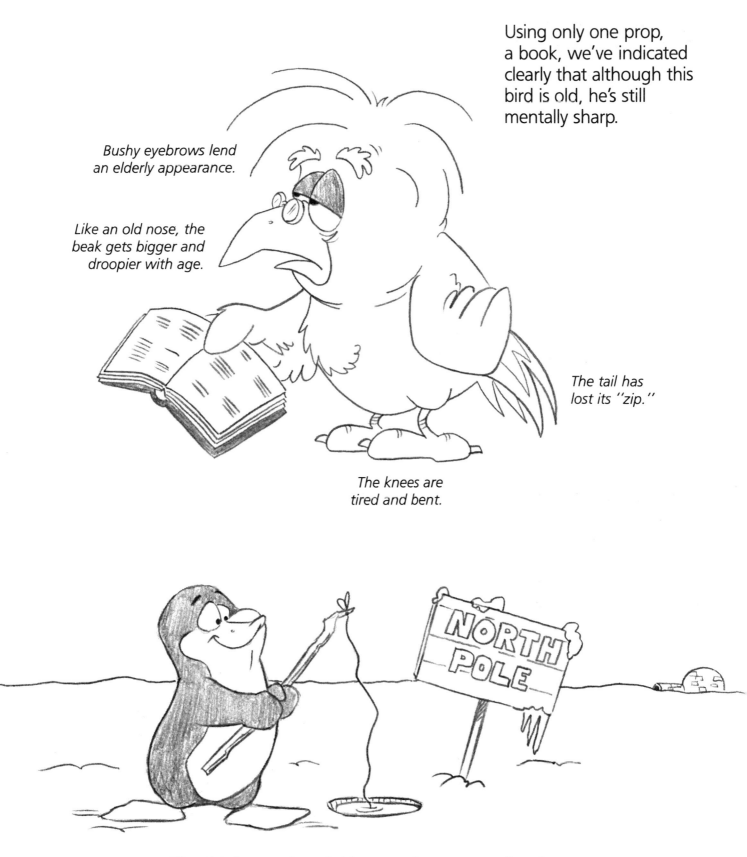

Using only one prop, a book, we've indicated clearly that although this bird is old, he's still mentally sharp.

Bushy eyebrows lend an elderly appearance.

Like an old nose, the beak gets bigger and droopier with age.

The tail has lost its "zip."

The knees are tired and bent.

NORTH POLE

The thigh muscles of this penguin connect directly to the foot; there is no knee joint. The result is a "waddle" in the character's walk. This is a good example of the "action line" principle we discussed on pages 40–41.

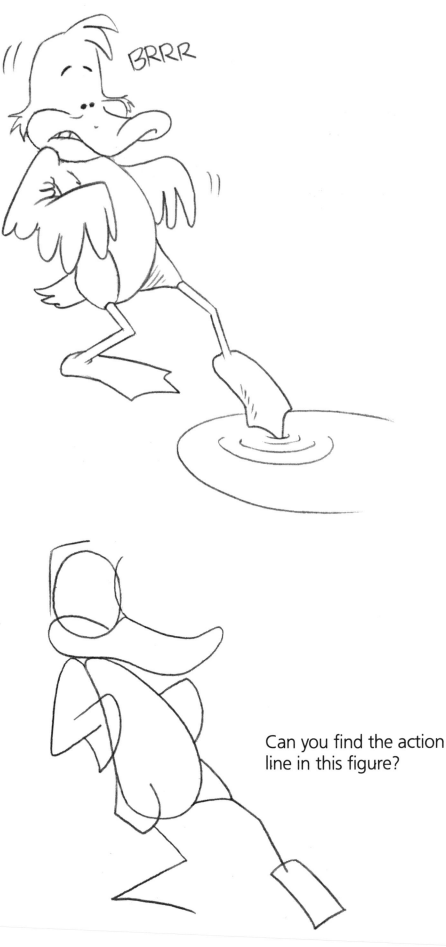

Have you ever seen a duck that was afraid of water? This is another example of using contradictions to create a humorous character: We've borrowed a strictly human body expression and used it on a duck. If you want to try another one, how about a bird that's afraid of heights?

Can you find the action line in this figure?

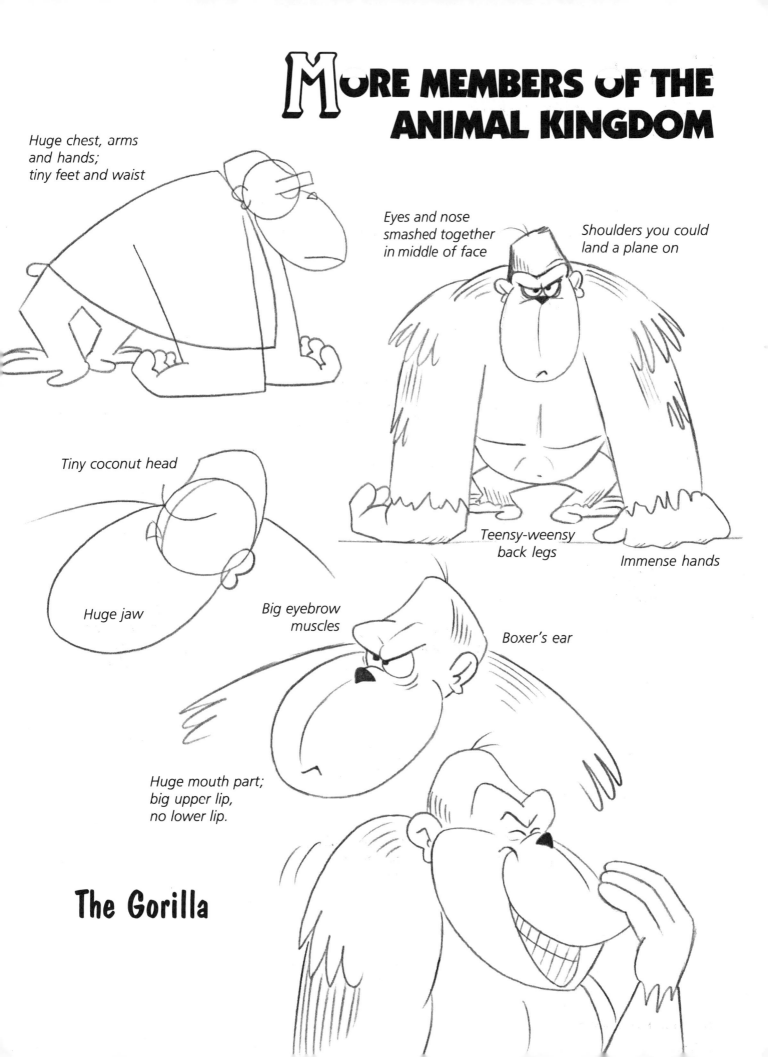

Huge chest, arms and hands; tiny feet and waist

Eyes and nose smashed together in middle of face

Shoulders you could land a plane on

Tiny coconut head

Huge jaw

Teensy-weensy back legs

Immense hands

Big eyebrow muscles

Boxer's ear

Huge mouth part; big upper lip, no lower lip.

The Gorilla

Elephant

Keep every part of him thick, fat, and round—except the tail.

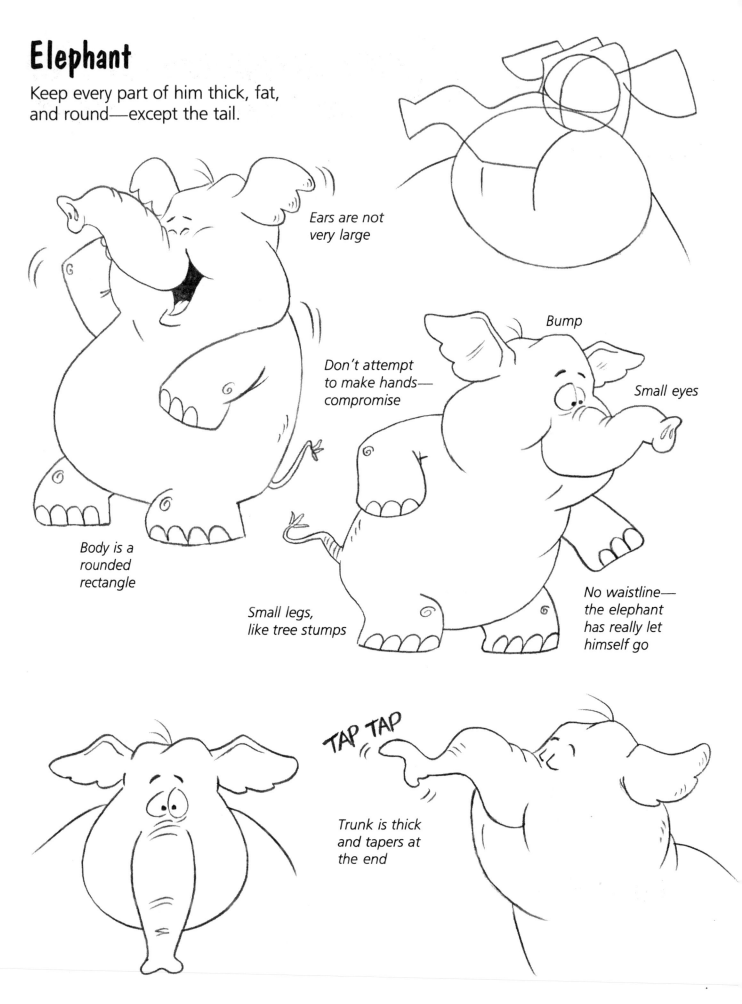

Ears are not very large

Don't attempt to make hands—compromise

Body is a rounded rectangle

Small legs, like tree stumps

Bump

Small eyes

No waistline—the elephant has really let himself go

Trunk is thick and tapers at the end

TAP TAP

Lion

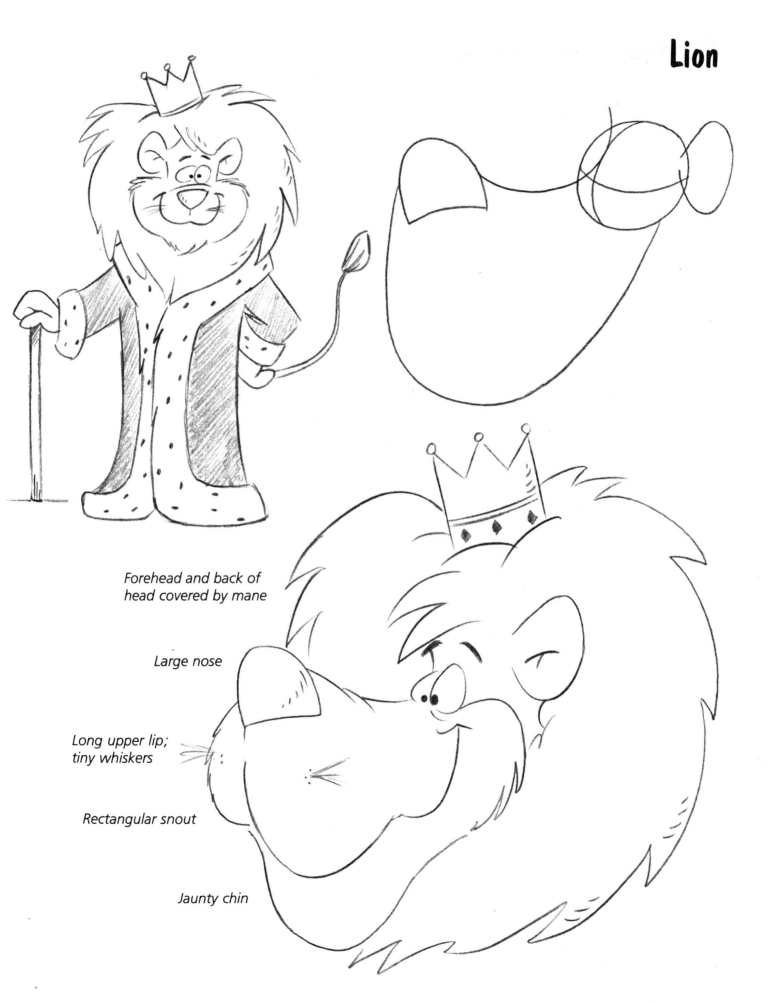

Forehead and back of
head covered by mane

Large nose

Long upper lip;
tiny whiskers

Rectangular snout

Jaunty chin

The Industrious Beaver

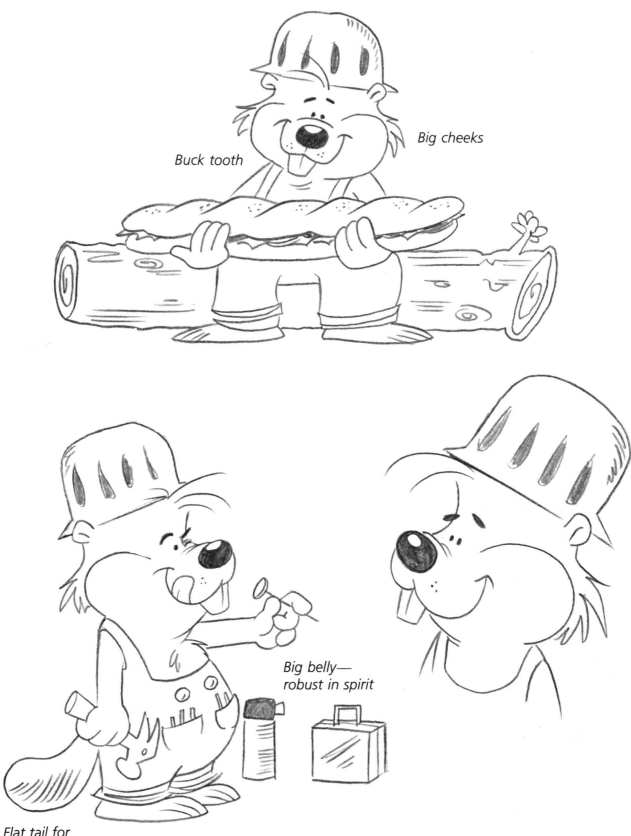

Buck tooth

Big cheeks

Big belly—
robust in spirit

Flat tail for
packing mud

Meet Spike, The Porcupine

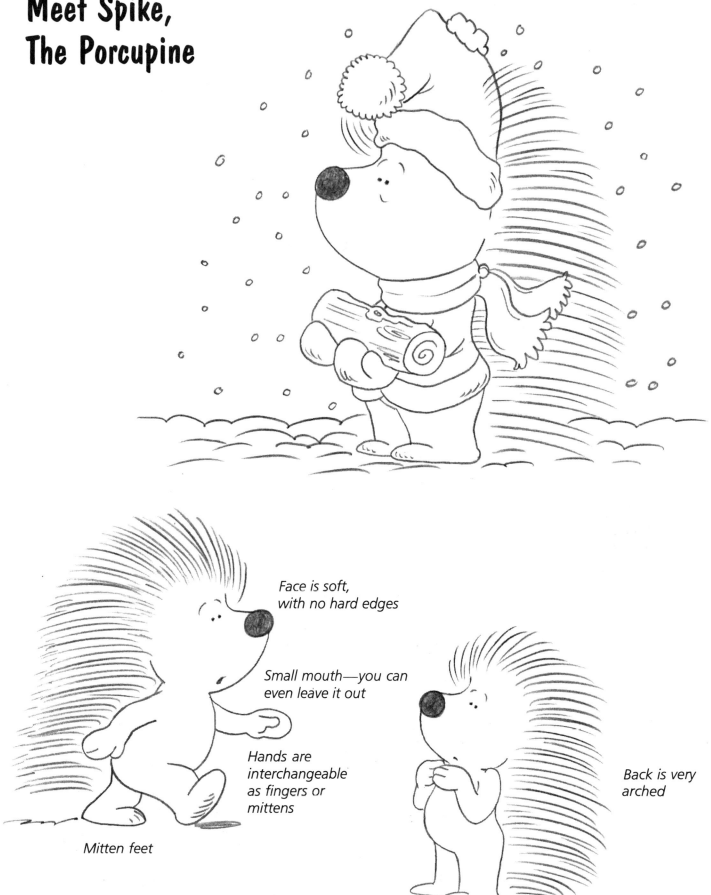

Face is soft, with no hard edges

Small mouth—you can even leave it out

Hands are interchangeable as fingers or mittens

Mitten feet

Back is very arched

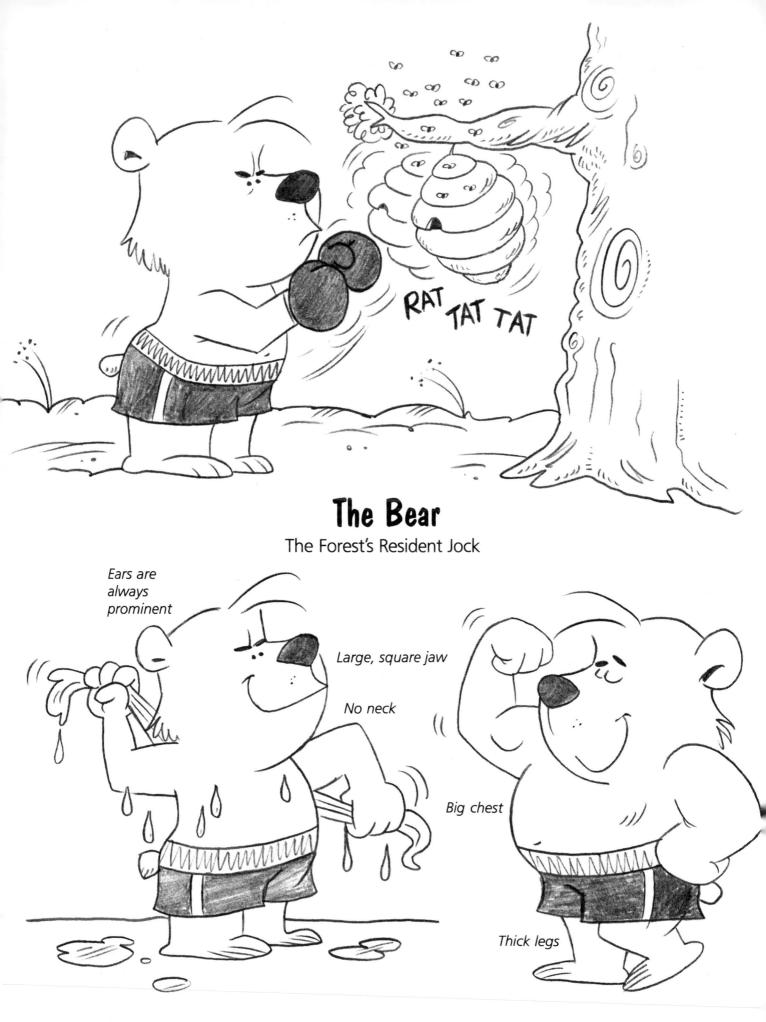

The Bear

The Forest's Resident Jock

A Lot of Bull

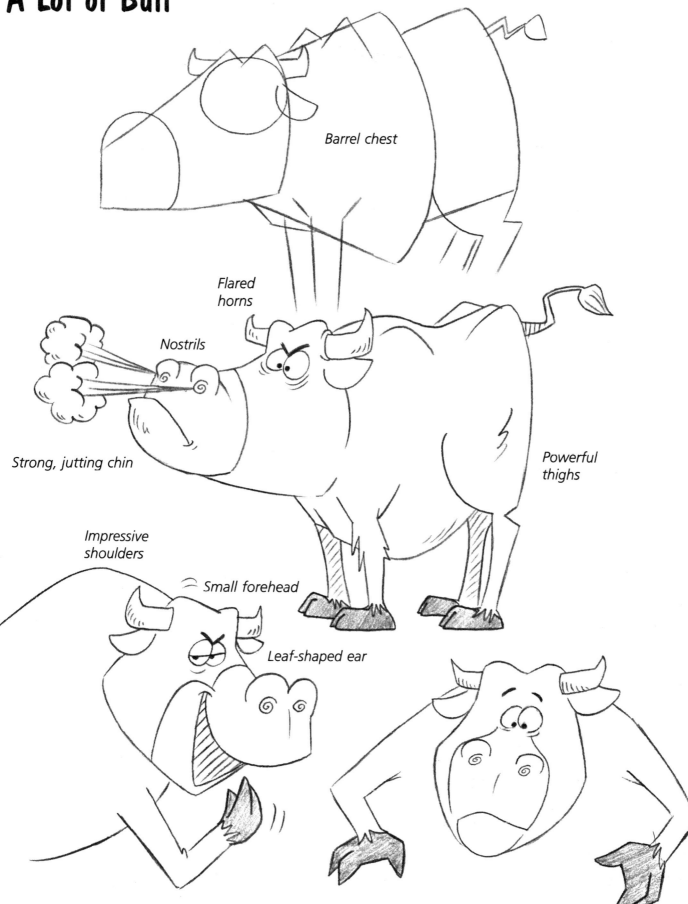

Barrel chest

Flared horns

Nostrils

Strong, jutting chin

Powerful thighs

Impressive shoulders

Small forehead

Leaf-shaped ear

Rabbit

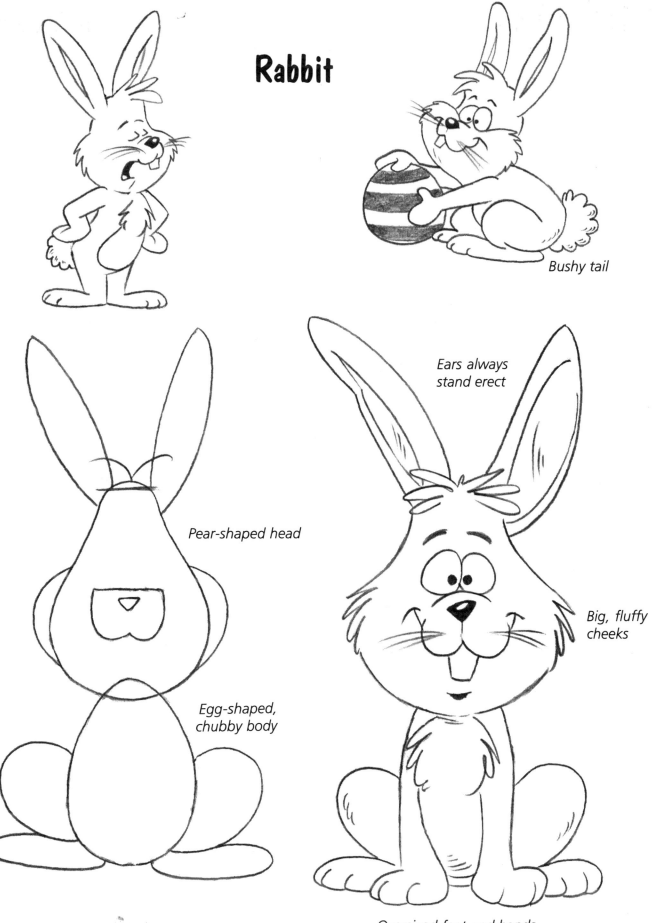

Bushy tail

Ears always stand erect

Pear-shaped head

Big, fluffy cheeks

Egg-shaped, chubby body

Oversized feet and hands

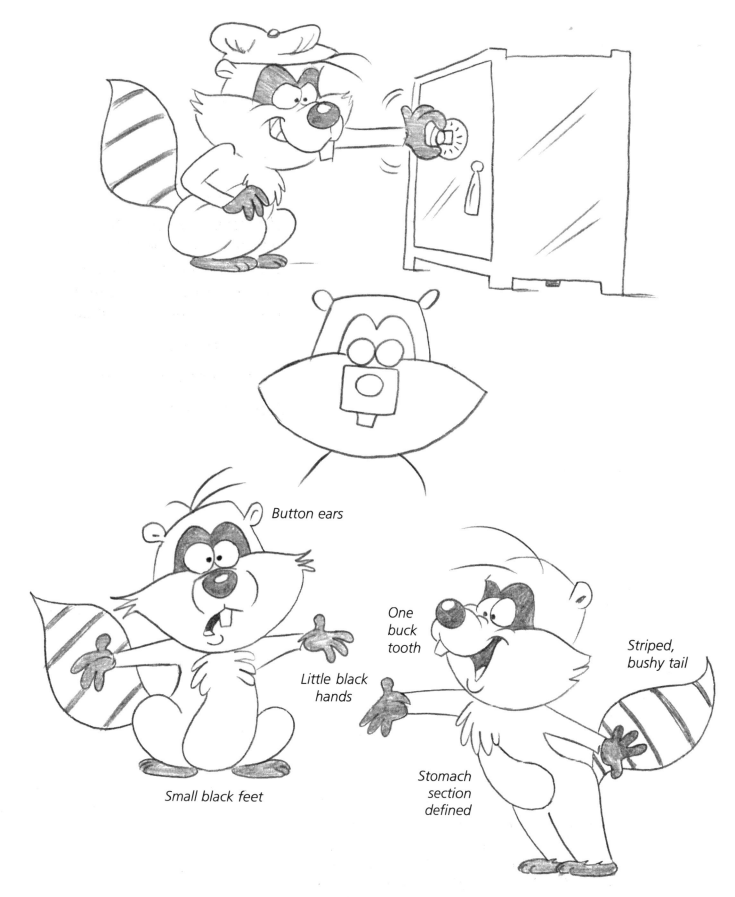

Button ears

One buck tooth

Little black hands

Striped, bushy tail

Small black feet

Stomach section defined

Horsing Around

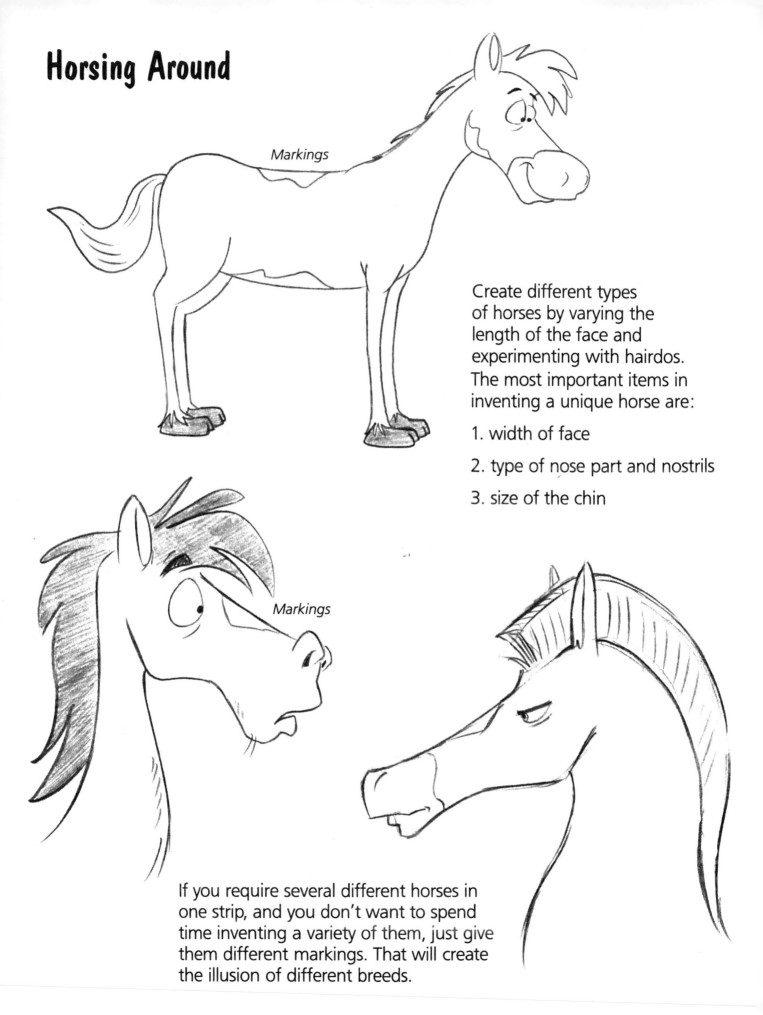

Markings

Create different types of horses by varying the length of the face and experimenting with hairdos. The most important items in inventing a unique horse are:

1. width of face

2. type of nose part and nostrils

3. size of the chin

Markings

If you require several different horses in one strip, and you don't want to spend time inventing a variety of them, just give them different markings. That will create the illusion of different breeds.

Although they come in many sizes and shapes, all mice share certain characteristics:

1. Big ears

2. Long tail

3. Big feet

4. Big cheeks

5. Big head (relative to body size)

6. Small or no chin

It seems as though a mouse's purpose in cartoon life is to annoy. If you put one in your comic strip, he's got to be making someone's life miserable.

The longer the mouse's snout becomes, the less cute he is, and the more he looks like a rat.

Hippos

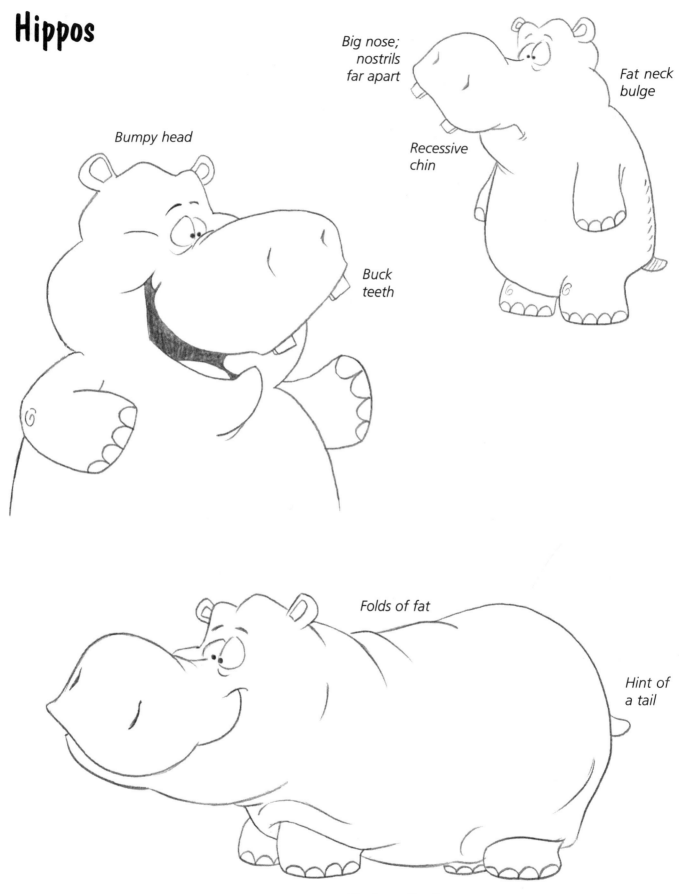

Bumpy head

Big nose; nostrils far apart

Fat neck bulge

Recessive chin

Buck teeth

Folds of fat

Hint of a tail

Elephant-like feet

Pig

Wide-eyed and inquisitive; remember, a pig is an intelligent animal!

Floppy ears

Like an elephant's trunk that never made the big leagues

Double chin

Jowls are a must!

Skull is a rounded rectangle

Jaw is a large circle

No neck

Arms are longer than legs

Body is a rounded rectangle

Keep the integrity of the hooves

The Walrus

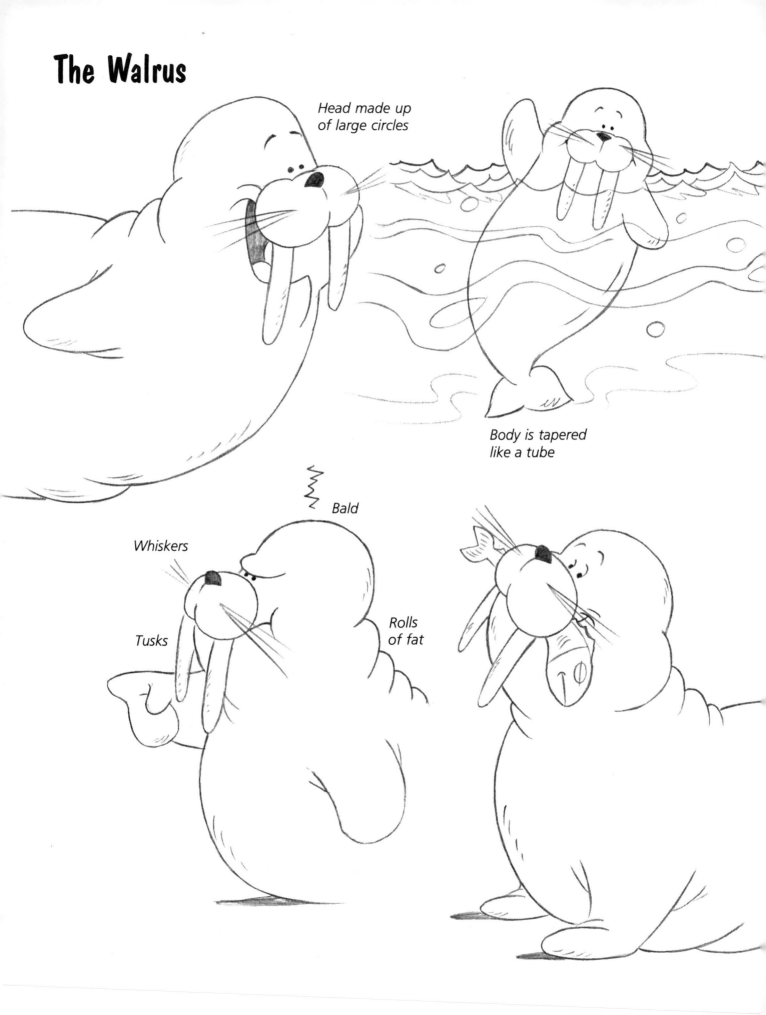

Head made up of large circles

Body is tapered like a tube

Bald

Whiskers

Tusks

Rolls of fat

Shark

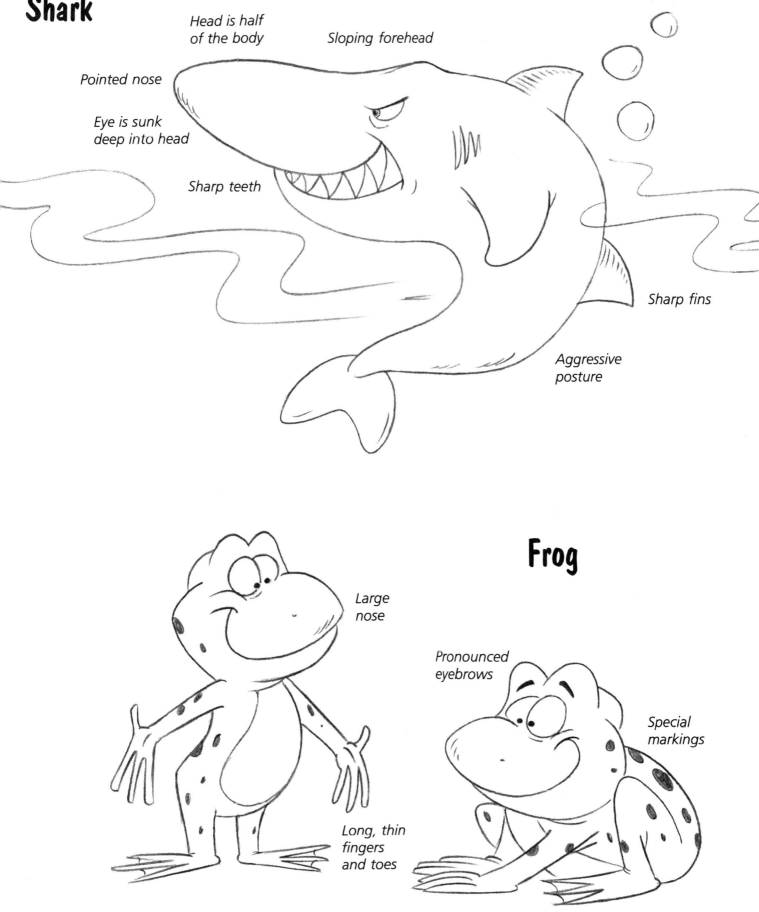

Head is half of the body

Sloping forehead

Pointed nose

Eye is sunk deep into head

Sharp teeth

Sharp fins

Aggressive posture

Frog

Large nose

Pronounced eyebrows

Special markings

Long, thin fingers and toes

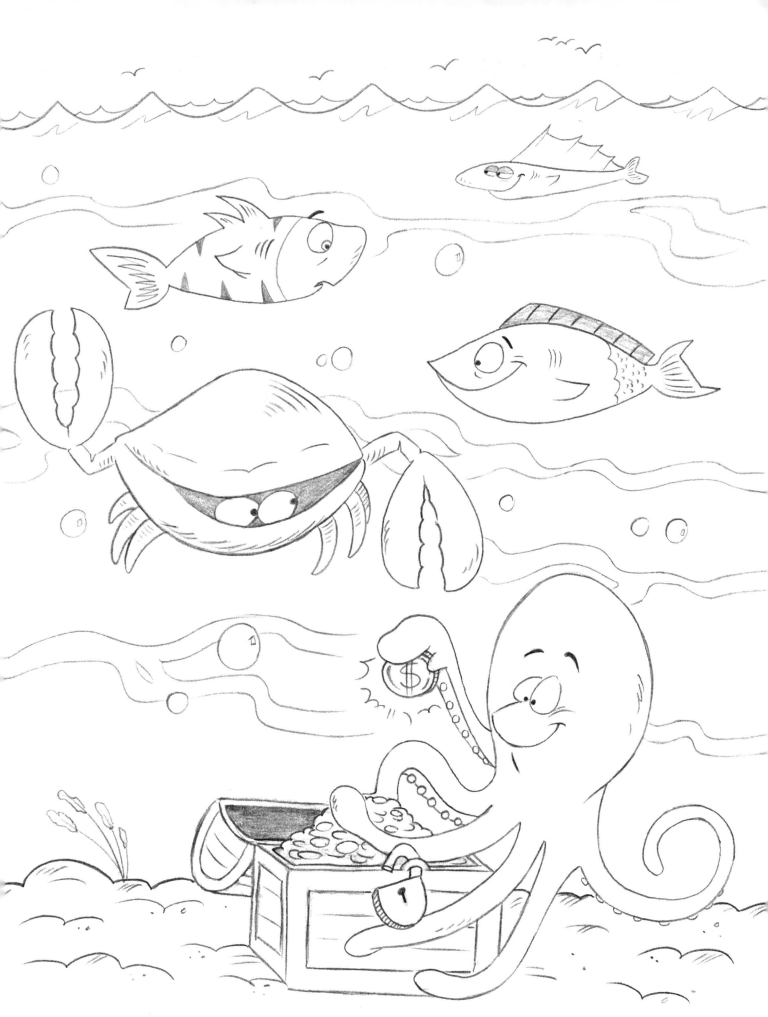

How to Make an Alligator out of a Crocodile

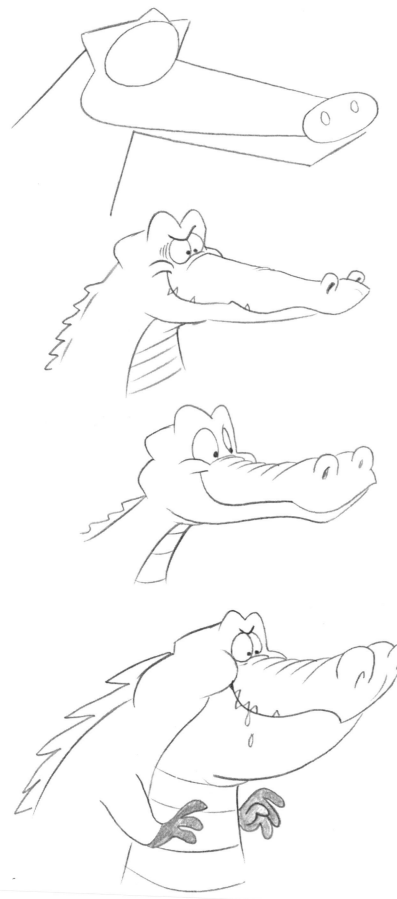

Basic Construction

Crocodile
Snout is tapered. Teeth show. Menacing look.

Alligator
Broader head. Snout doesn't taper. If your character is friendly, choose an alligator over a crocodile. (Remove teeth for an affable 'gator.)

Fat Alligator
To make an alligator fat, simply drop its chin and neck, but keep the snout and forehead as is.

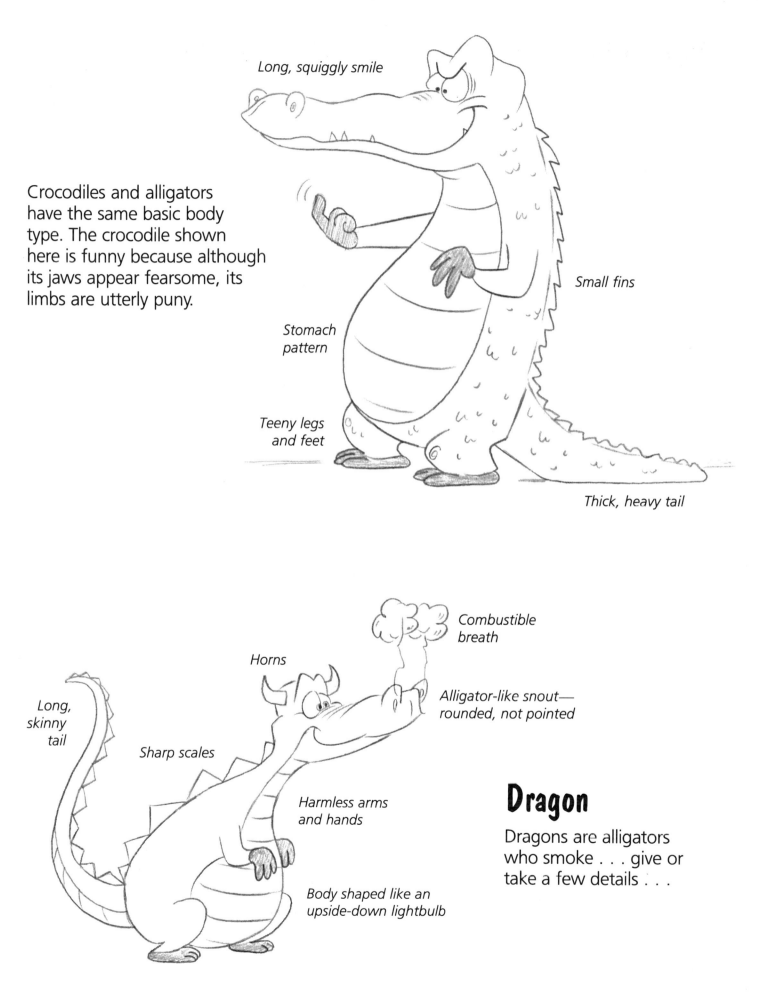

Long, squiggly smile

Crocodiles and alligators have the same basic body type. The crocodile shown here is funny because although its jaws appear fearsome, its limbs are utterly puny.

Small fins

Stomach pattern

Teeny legs and feet

Thick, heavy tail

Combustible breath

Horns

Alligator-like snout—rounded, not pointed

Long, skinny tail

Sharp scales

Harmless arms and hands

Dragon

Dragons are alligators who smoke . . . give or take a few details . . .

Body shaped like an upside-down lightbulb

Tortoise

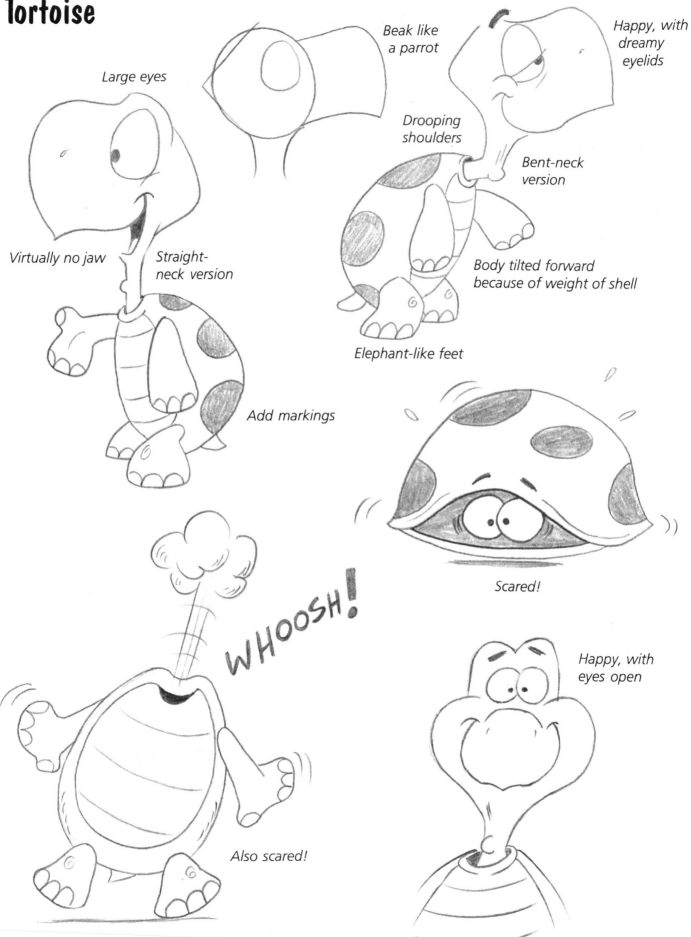

Large eyes

Beak like a parrot

Happy, with dreamy eyelids

Drooping shoulders

Bent-neck version

Virtually no jaw

Straight-neck version

Body tilted forward because of weight of shell

Elephant-like feet

Add markings

Scared!

WHOOSH!

Also scared!

Happy, with eyes open

THE COMIC STRIP

By now, you should be familiar with the cartoonist's approach to drawing. In fact, there are probably a few characters that you can draw without referring to any instructions. Maybe you've even invented some characters of your own. Now it's time to put those characters to use in a comic strip. On the following pages are basic rules that will lead to good, solid comic strip art. These guidelines will help you make your comic strip visually appealing.

Remember that rules are broken every day by adventurous comic strip artists. But an artist must know the rules in order to selectively break them. In any event, no comic strip, no matter how modern, breaks more than one or two of these rules in any given panel. Your best source of information, outside of this book, is the funny pages of your newspaper.

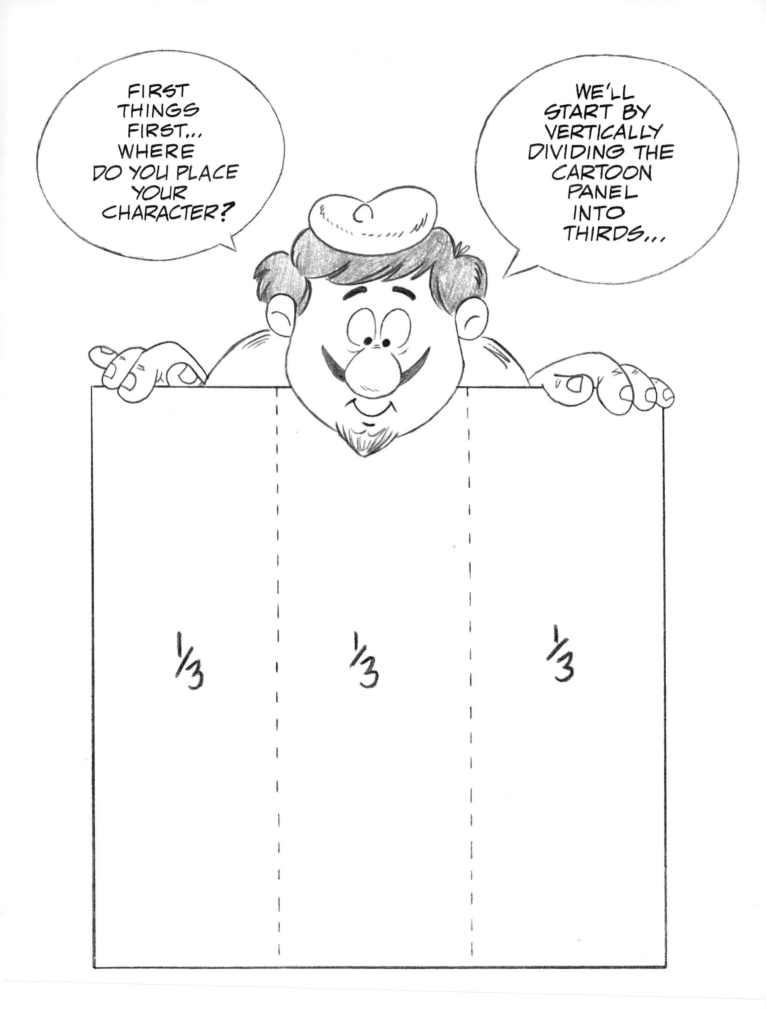

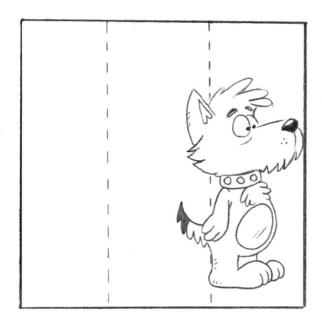

What's Wrong with This Picture?

Because this guy is placed so far to the right, he's boxed in by the sides of the panel. There's no breathing room, and the character's placement feels uncomfortable.

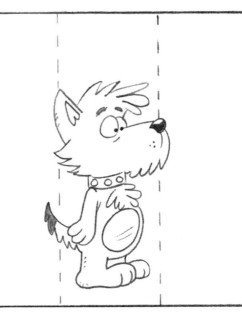

Better . . . but boring. Anything that's placed smack in the middle usually comes across as mild and tame.

Eureka! Not only does the character now have enough room, but his dialogue balloon does, too. Since people read from left to right, a character placed on the left side of a panel will naturally lead the eye to the right, toward the rest of the panel.

Most comic strips are made up of a series of three or four panels strung together, but you don't have to start with three panels. Build a foundation by practicing with a single panel. When you feel confident handling one panel, string three panels together to make one continuous story, and you've got a legitimate comic strip!

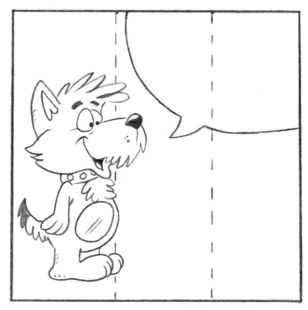

Now look what happens when your character is facing forward. This character will not lead the reader's eye to the left or to the right. Therefore, he can stand on either the left or the right side of the panel: it makes no difference.

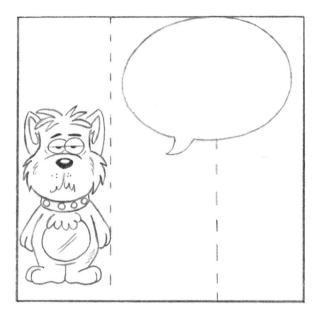

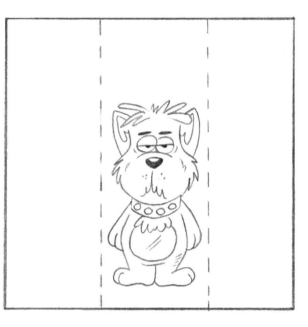

He cannot, however, stand in the middle. Such a placement leaves no space for the dialogue balloon.

This is okay, but remember, this placement only works when your character is facing straight ahead.

THE HORIZON LINE

It's amazing that one line can put an entire scene into perspective, but that's exactly what the horizon line does. "Horizon line" is a fancy way of saying "ground." The horizon line also determines the location of the sky; in a drawing, everything above the ground reads as sky. Of course, if you add mountains and buildings, this direct ground-sky relationship is broken up.

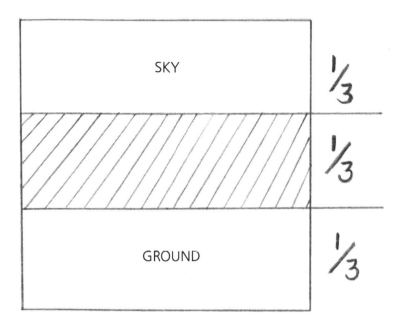

SKY

$\frac{1}{3}$

$\frac{1}{3}$

GROUND

$\frac{1}{3}$

The horizon is too low. The character looks like he's on a tightrope.

The horizon is too high. Such a high horizon line creates the illusion that the background is coming forward and makes the drawing appear flat.

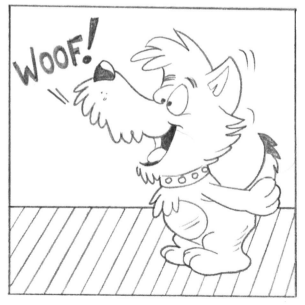

WOOF!

This is the most comfortable formula: two-thirds sky and one-third ground.

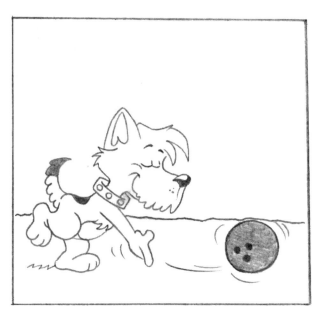

Long (or full) shot:
Entire body is shown

Everybody is influenced by film and TV, and comic strip artists are no exception. Comic strip characters used to be drawn from head to foot in each panel, but this is no longer so. If a character's expression is very important, you may want to show only his face. This is a close-up. On the other hand, if the character's movement is key to the panel, you'll want to show the entire body—a long shot. And if a character is interesting, but his legs aren't doing much, you might choose a medium shot. A medium shot is often a good change of pace and can act as a bridge between a long shot and a close-up. Going from a long shot directly to a close-up can be visually jarring.

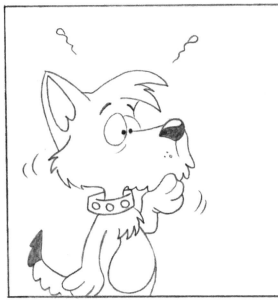

Medium shot:
From waist, or chest, up

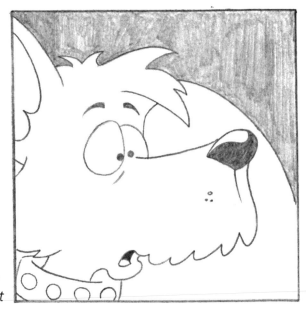

Close-up:
Head shot

Specialty Shots

Specialty shots are just that—special. They're to be used sparingly for an added punch. They're fun, so don't be afraid of experimenting with them.

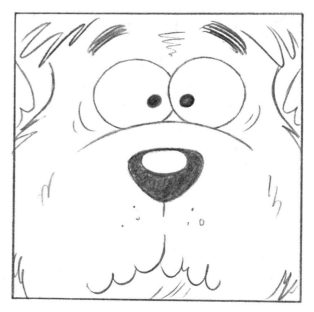

Detail shot
A close-up of some-thing, usually some-thing that was referred to in a prior panel. If an object—in this case, a bone—is important to the gag, you might emphasize it by showing it alone so the reader can't miss it.

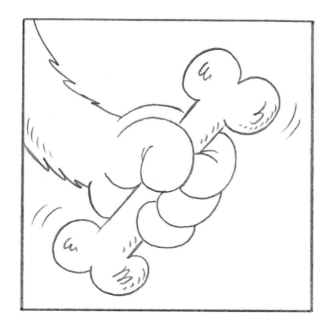

Extreme close-up
This really wakes up the reader. With this shot, you're prac-tically sticking your cartoon character in the reader's face!

Extreme long shot
Another change-of-pace shot. This shot can comfortably ac-commodate a high horizon line.

The Silhouette

Silhouettes are an excellent way to vary the visuals when there isn't a whole lot of action going on in the comic strip gag. Silhouettes are used only in middle panels. If you use a silhouette as the first panel the reader won't be able to see your characters' faces and may lose interest. If you use a silhouette as the final panel, the reader will be unable to see the delivery of the punch line and the other character's reaction. Silhouettes are most effective when used in extreme long shots.

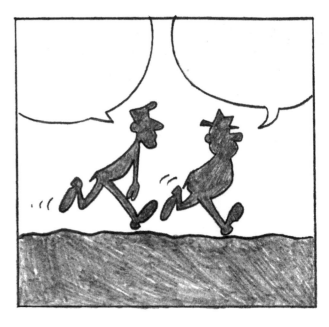

Horizon Line (Again!)

Horizon lines can be used in any size shot (except for an extreme close-up, where the face fills the entire panel). See how the horizon line adds depth to the close-up drawing of this hard hat.

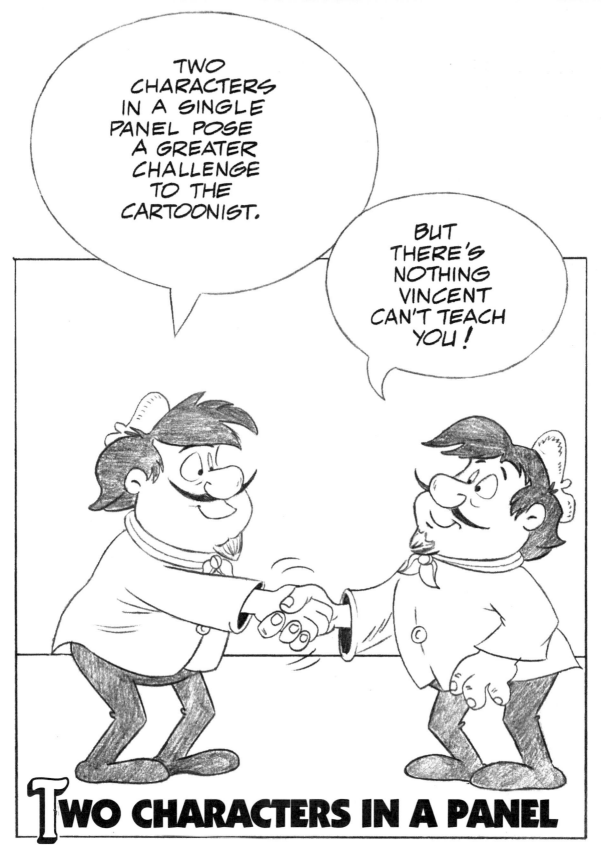

TWO CHARACTERS IN A PANEL

When you introduce a second character in a panel, the result can be either added interest or complete disaster. To avoid chaos, remember one word: *interaction*. When you've got two characters in a panel, you have to show them relating *physically* to each other. It's that simple. The characters don't have to touch—they can even ignore each other—but whatever they're doing, both subjects must seem involved with the action.

Long Shots with Two Characters

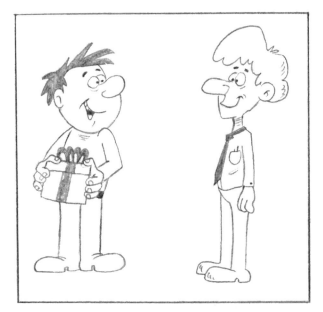

Friendly pose: *Characters face each other from opposite ends of the panel.*

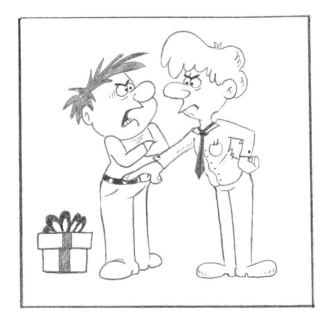

Angry pose: *Characters face each other nose-to-nose in the middle of the panel.*

Casual conversation: *One character talks to another who is in the middle of performing an action.*

Delivering a punch line: *Character darts back into the panel, adding extra energy to the punch line.*

Moving in tandem: *Characters walk with the same gait in the same direction.*

Ignoring each other: *Characters are back-to-back but close together.*

Foreground/background: *One character is in the foreground, while the other appears smaller, in the background.*

Diagonals: *Variations in height, due to differences in size or position, create diagonals, which add interest to the characters' physical relationship.*

Medium Shots with Two Characters

The interruption: *A character turns around as someone addresses him from behind.*

Secret thought: *While one character gazes out into space, the other schemes secretly, revealing his hidden agenda only to the reader, who becomes a confidant.*

Face to face confrontation: *Notice that the horizon line, which is a severe diagonal, underlines the emotional imbalance between the characters.*

Corresponding reactions: *Two characters react in the same way to the same stimulus. They face in the same direction and share a single dialogue balloon.*

Reverse Angles

Because the effectiveness of reverse angles is dependent on a previously established relationship between characters, reverse angle panels are used only as a bridge between two other panels. The reverse angle panel puts one character in sharp focus, thus directing the reader's eyes at that character and nowhere else. Reverse angles also serve the purpose of drawing the eye into the background, providing a feeling of depth.

Ordinary medium shot

Reverse angle medium shot

Ordinary long shot

Reverse angle long shot

Note that the panel borders on this page are hand-drawn. Although the majority of comic strips have ruler-straight borders, it's up to you to choose the style that works best.

THE IMPORTANCE OF BLACKS AND WHITES

Nothing makes a strip stand out more on the page than the bold use of blacks and whites. The larger the areas that are blackened, the more obvious they are. But don't overdo it—a comic strip with too much black will look dark and gloomy. The best way to achieve balance is to "checkerboard" the blacks and whites. You can see the effects of checkerboarding in this drawing.

When there's nothing in the background that can be used to heighten the visual contrast of the panel, you can improvise. This is archway shading, a very popular technique among cartoonists. Simply add an archway to the background and shade it in. Immediately, your composition becomes more dramatic.

Another way to add black-and-white interest is to simply add a block of shading in the middle of your panel. The variations are limitless. Experiment with some of your own.

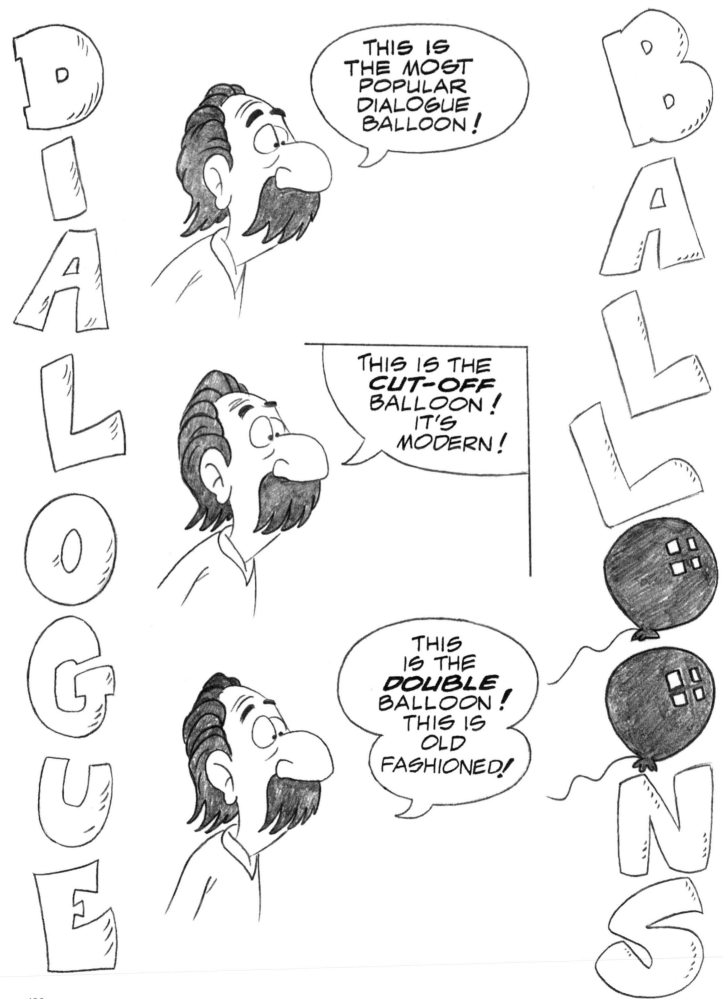

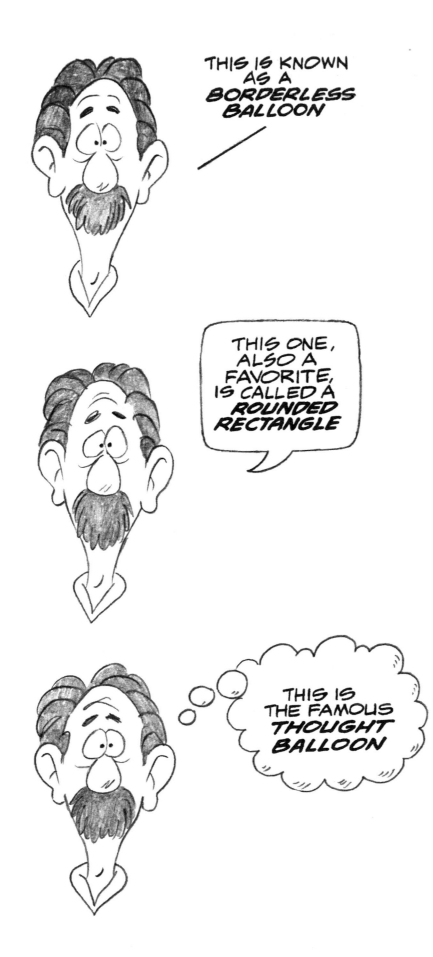

THIS IS KNOWN
AS A
*BORDERLESS
BALLOON*

THIS ONE,
ALSO A
FAVORITE,
IS CALLED A
*ROUNDED
RECTANGLE*

THIS IS
THE FAMOUS
*THOUGHT
BALLOON*

This balloon is used for inanimate objects like TVs and phones.

RING

POW

This is an ACTION BALLOON for sound effects. It has no spout.

Hints

THE SPACING OF THE WORDS IN HERE IS TOO CLOSE FOR COMFORT!

Leave enough room between the borders of your dialogue balloon and the lettering inside.

HEY, BABE, COME HERE OFTEN?

NOT ANYMORE!

Don't mix different styles of dialogue balloons. Pick one type and stick to it. You want to develop a recognizable style. If you continually switch dialogue balloons, your strip will lack a definitive look.

(SPOUT)

THE LONGER THE SPOUT, THE WEIRDER IT LOOKS!

Keep the spouts to your dialogue balloons short and direct.

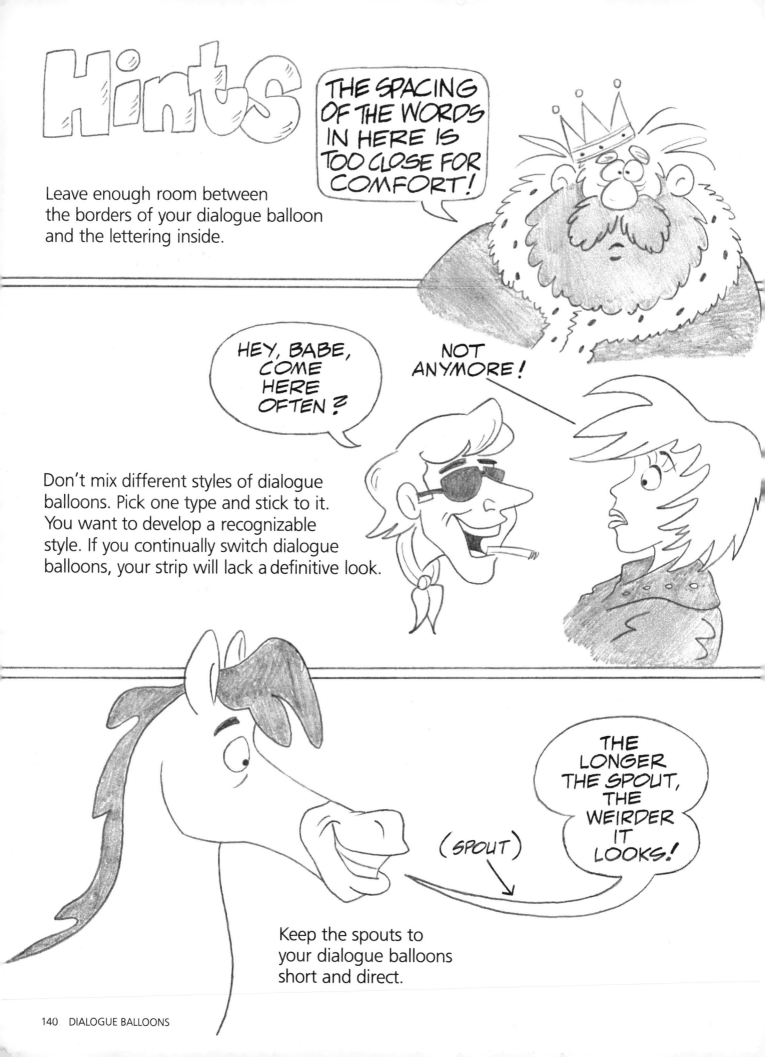

There are only two rules in comic strips that may never be broken:

1. The character who speaks first has the dialogue balloon farthest to the left.

2. The character speaking second has the lower balloon.

For a more interesting composition, you can overlap a character's face onto his dialogue balloon.

When pressed for space, you can either overlap dialogue balloons . . . or . . . you can break the borders of one of the middle panels and shift your balloon slightly into the next panel.

SAMPLE LAYOUTS

Standard, old-fashioned panel arrangement

Modern three-panel setup

Variation

NOTE: The above layouts are suggested formats, but you should be drawing your strips on a larger sheet of paper than this book will allow. The total overall size of a comic strip should be 3⅞" × 13". Reduce it by 100% on a copying machine to get the actual size as it appears in the newspaper.

Small second panel used for a sound effect or a close-up shot

For a big punch line scene

Borderless panel

INDEX

Edited by Brigid Mast
Designed by Bob Fillie
Graphic production by Hector Campbell
Text set in 14-point Frutiger 45